PARIS CHANGING

Christopher Rauschenberg

PARIS

CHANGING

Revisiting Eugène Atget's Paris

With essays by Clark Worswick, Alison Nordstrom, and
Rosamond Bernier

Princeton Architectural Press, New York

Published by
Princeton Architectural Press
37 East Seventh Street
New York, New York 10003

For a free catalog of books, call 1.800.722.6657.
Visit our website at www.papress.com.

All photographs by Christopher Rauschenberg unless otherwise noted.
Courtesy the Bibliothèque nationale de France: front cover (bottom left),
pages 8 (top and bottom left), 20, 24, 26, 28, 30, 34, 36, 42, 44, 48, 50, 52, 54, 56,
58, 60, 66, 70, 80, 90, 92, 94, 104, 108, 112, 118, 120, 126, 138, 148, 150, 152, 154,
156, 158, 160, 162, 164, 166, 168, 170, 172, 174, 176
Courtesy the Parisienne de Photographie: front cover (top left), back cover
(left), pages 22, 32, 38, 40, 46, 62, 64, 68, 72, 74, 76, 82, 84, 86, 88, 96, 98, 100,
102, 106, 110, 114, 116, 122, 124, 128, 130, 132, 136, 140, 142, 144

Editing: Nicola Bednarek
Design: Jan Haux
Maps: Matt Knutzen

Special thanks to: Nettie Aljian, Sara Bader, Dorothy Ball, Janet Behning,
Becca Casbon, Penny (Yuen Pik) Chu, Russell Fernandez, Peter Fitzpatrick,
Wendy Fuller, Clare Jacobson, John King, Nancy Eklund Later, Linda Lee,
Katharine Myers, Lauren Nelson Packard, Jennifer Thompson, Arnoud
Verhaeghe, Paul Wagner, Joseph Weston, and Deb Wood of Princeton
Architectural Press —Kevin C. Lippert, publisher

Library of Congress Cataloging-in-Publication Data
Rauschenberg, Christopher, 1951–
Paris changing : revisiting Eugene Atget's Paris / Christopher
Rauschenberg ; with essays by Clark Worswick, Alison Nordstrom, and
Rosamond Bernier.
p. cm.
ISBN-13: 978-1-56898-680-7 (alk. paper)
ISBN-10: 1-56898-680-7 (alk. paper)
1. Photography, Artistic. 2. Paris (France)—Pictorial works.
3. Rauschenberg, Christopher, 1951– 4. Atget, Eugène, 1857–1927. I. Atget,
Eugène, 1857–1927. II. Worswick, Clark. III. Nordström, Alison Devine. IV.
Bernier, Rosamond. V. Title.
TR654.R3386 2007
779'.944361—dc22

 2007005569

Contents

Acknowledgments

First of all, I would like to thank my mother, Susan Weil Kirschenbaum, who taught me photography and taught me to love Atget. I would also like to thank my agent Robert Morton for believing in the idea; Alison Devine Nordstrom for making a "dream come true" exhibition of this project at the George Eastman House; Françoise Reynaud of the Musée Carnavalet for helping me to find the reproduction prints used in this book; and Mark Klett, Ellen Manchester, and JoAnn Verburg for inspiring rephotographers everywhere. The Bibliothèque nationale de France and the Photothèque des musées de la Ville de Paris kindly granted permission to reproduce the photos by Atget contained in this book.

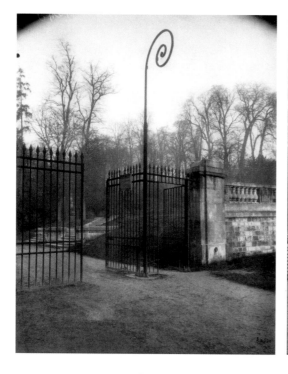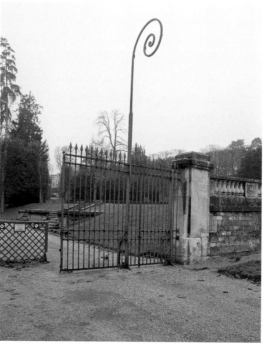

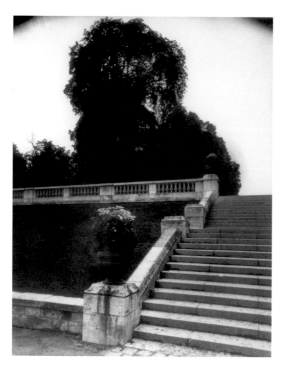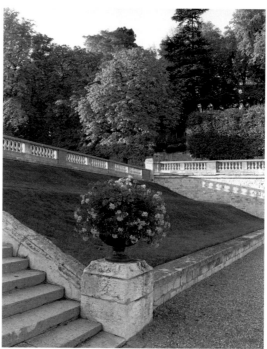

Preface

Christopher Rauschenberg

Eugène Atget photographed Paris from 1888 until his death in 1927. Like many people, I consider him the greatest photographer of all time. He documented the city in a straightforward way, his images evoking the feeling that all the transitory things that people make, all the things they do, are washed away, leaving only their transcendent evidence.

I have known Atget's works from my earliest days as a photographer, seeking them out in books and museum shows whenever possible. On a trip to Paris in 1989, I suddenly found myself face to face with a spiral-topped gatepost that I knew very well from a photograph by Atget (opposite, top left). I rephotographed his gatepost from memory (opposite, top right) and wondered how many other Atget subjects might still be holding their poses. When I found a familiar-looking stone stairway in another neighborhood, I looked around for the huge, beautiful tree that in Atget's photograph (opposite, bottom left) loomed over a flower vase on a corner post, but I could not find it. The flower vase on the other side of the stairs, however, did have a tree behind it, so I photographed that side instead (opposite, bottom right). I wanted to match the poetic meaning of the image more than I wanted to show that the magnificent tree was gone.

In Paris that year, in the streets and places that Atget had admired, I resolved to return and explore with my camera whether the haunting and beautiful city of his vision still existed. Between 1997 and 1998, I made three trips to Paris and rephotographed five hundred of the outdoor scenes that Atget had photographed. (I could not, of course, revisit the interiors that he had pictured or recapture the people in his views.)

In this book seventy-five of the pairs of images are published, clearly showing that the Paris of Atget's vision still exists and is available to eyes that look for it. In central Paris, in particular, most of the places that Atget photographed are still there, and still posing. You can see the effects of weathering and acid rain on them; you can see the disrespectful marks of graffiti; and most of all, you can see that the magical streets of the city are choked with traffic and parked cars. However, among all the other Parises that coexist so thickly in one amazing metropolis, Atget's Paris is still definitely and hauntingly there.

Revisiting Eugène Atget's Paris

Clark Worswick

Practically no artist I know of has left the world with what is commonly received as the seminal vision of an epoch. Yet, just such a vision was left by perhaps France's greatest photographer of the twentieth century, Eugène Atget. His documentation of Paris between the years 1897 and 1927 defined not only a city but an entire era—France's *belle epoch*. Born in 1857, Atget was, by unlikely turns, first a cabin boy and then a sailor on the French *Transatlantic* runs. He later became a provincial actor and, finally, a photographer. The curiosity of his great accomplishment is that during the first part of the twentieth century, so neglected and modest was his work, so lonely was his obsessive grand passion for the documentation of Paris that the artist virtually starved to death. When he died in 1927, Atget had been utterly forgotten by his contemporaries except for a few of his closest friends.

Today, eighty years after his death, we realize how this humble "street photographer" changed the way we look at both modernism and art. Aside from the manifest debts that modernism owes him, Atget left us with a vision of the world he inhabited that is both particular and unique. But despite his monumental œuvre we know very little about Atget and his motivations for undertaking his life's work.

Atget was born in the southwest region of Gironde in Libourne in 1857. Orphaned at the age of seven, he was raised by his uncle, who was a stationmaster in the department of railways. Making a living first as a cabin boy and as a sailor, he later became a member of a provincial theatrical repertory company and finally settled in Paris sometime in the mid-1890s, where he purchased his first camera in 1897. It was made of walnut and had a rapid rectilinear lens that captured images on 18-by-24-cm photosensitized glass plates. The impetus that appears to have sparked Atget's interest in photography was a historical commission from the municipality of Paris to document the sections of old Paris, though how he got this commission is unknown. This work marks the beginning of his career as a photographer, but even though innumerable historians have studied Atget and his work, we know nothing about *why* he chose this profession. A closer examination of his work habits and life is a slow process—like peeling back an onion layer by layer—and at the end one is left with nothing so much as mysteries of the human heart. We know only the barest facts of how Atget came to define his subtractive, objectivist vision. And we know even less about what impelled him to produce the great work that came to consume the last three decades of his life.

In undertaking his documentation of Paris, Atget followed in the well-trodden footsteps of a number of other French photographers whom he had perhaps never heard of. Chief amongst them were Charles Nègre, Edouard Baldus, and Gustave LeGray. Charles Marville, who also began working in the 1850s, produced a suite of photographs of Paris in connection with Baron Haussmann's "renovation" of the city in the 1860s, which radically changed its physical look. During the same decade, the Bisson brothers also made important photographic documents of Paris and its buildings.

Though images of European urban buildings and cityscapes were much in vogue during the 1850s through the 1890s—the works of J. Craig Annan in Glasgow, Dixon & Boole in London, and Robert MacPherson, James Anderson, and Fratelli Alinari in Italy come to mind—by the time Atget took up photographing Paris between 1897 and 1899, the documentation of European urban subjects by commercial photographers was drawing to a close. During the later part of the 1890s, an era that increasingly came to be dominated by amateurs wielding Kodak cameras, the world-wide demand for commercial photography of urban scenes went into a steep and radical decline. Somehow, however, by some fluke of a problematic spirit, Atget's career as a documentarian of Paris flourished at that exact moment.

After his 1897 work for the commission to document historic Paris, Atget managed to sell pictures in 1899 to the Musée Carnavalet, a museum devoted to the history of Paris. Having formed a connection with this established museum, in the next decades he would sell his photographs to a range of institutions, among them the Bibliothèque Historique de la Ville de Paris, the Bibliothèque National, the Bibliothèque de l'Ecole des Beaux-Arts, the Ecole Boulle, the Bibliothèque du Musée de Sculpture Decoratifs, and the Musée du Sculpture. Early in his career Atget also worked on photographs that he called *documents pour artistes,* which were bought and used as pictorial motifs by the painters Maurice Utrillo, André Dunoyer de Segonzac, Georges Braque, André Derain, and Maurice de Vlaminck, as well as Man Ray during the 1920s. These images certainly contributed to and shaped Atget's vision of the documentary.

His most important œuvre, though, would occupy the photographer for thirty years. Between 1897 and 1927, capturing the life and scenes of Paris with his modest plate camera and tripod became something like Atget's private work, which he pursued daily on his solitary rounds around the city. It became Atget's grand and impossible mission to preserve everything in Paris that was evanescent and vanishing from the *ancien régime*: the architecture—the city's great public buildings, churches, residences, restaurants, and stores—its people and their trades, as well as its vehicles. He often documented empty streets bereft of inhabitants at dawn and dusk. Sometimes I think of Atget as a kind of grand, agitated botanist dividing an entire city into phylum and sub-phylum where each species is categorized, named, and described. Atget's patience was almost glacial—I know of no other photographer

among his contemporaries who embarked upon such a vast project of a single place. He even took pictures of the root structure of trees and the foliage of Paris at different seasons. Nothing escaped his eye.

Although Atget sold his photographs, he received very little for them. Still, he managed to continue his project and thus was free from the usual constraints that come with a commercial photographer's clientele. In his work, he traveled into realms that no photographer had ever traversed. On his fragile glass plates, with his old-fashioned plate camera, Atget photographed the streets and shops of Montmartre and the Quartier Latin; he photographed shop window displays, *bourgeois* interiors, merry-go-rounds, and the gardens of the city as well as Versailles, St. Cloud, and Fontainebleu. He took thousands of photographs of buildings that lined the streets of Paris and their embellished facades. He paid particular attention to the decorations of Parisian architecture in the form of door knockers, shop signs, ornately carved doorways, grills, elaborately worked glass windows, staircases, stucco ornamentations, and courtyards. Over time, his passion for documenting came to encompass the entire city.

During his working life as a photographer, Atget had a diverse clientele, ranging from set designers, artists, and antiquarians, to the building industry, publishers, and academics. Today, books published with his photographs have appeared in almost countless numbers in literally scores of languages, and it has become commonplace to reference the city of Paris and Atget's documentation of it in the same sentence. His work has come to symbolize both objectivism in modern art and the look of France's *belle epoch.* This vision of Paris's recent past is not only populated by many of France's greatest architectural treasures but also—though they are not shown in this book—by a vast gallery of Parisian human types ranging from street singers to gypsies, basket sellers, peasants harvesting their crops, rag pickers, prostitutes, and Parisian street pavers.

The photographic historian Molly Nesbit has laboriously counted the number of prints that Atget sold to the different organs of the French state—some 16,758 prints are held by various French institutions. Nevertheless, at the time of his death Atget was so forgotten that not a single volume of his work had appeared since he had self-published the portfolio *L'Art dans le Vieux Paris* in 1909. In 1927, after Atget's death, his executor André Calmette sold for an unrecorded amount some 8,000 prints and 1,400 negatives to the young American photographer Berenice Abbott, who apparently was the one person in the world still interested in Atget's life's work. For the next forty years Abbott spent much of her time making the world aware of Atget's great achievement. In a saga that is almost breathtaking in its dedication—receiving few rewards and mostly indifference—Abbott arranged exhibitions of Atget's photographs, encouraged the publication of books about his work, and in her darkroom

painstakingly continued to reproduce the forgotten photographer's images. One of the best technicians of her generation, she made carefully crafted prints of her own selection of Atget's negatives on heavily impregnated silver-coated photographic papers. But not only was Abbott unfailing in her efforts to make Atget's work known to the world, she was also inspired by him to undertake her own documentation of a city—that of Depression-era New York.

Finally, in the late 1960s, the Museum of Modern Art in New York approached Abbott to buy her collection of Atget's works. In order to be able to afford printing Atget's negatives and mount exhibitions of his work, Abbott had, during the early years of the Depression, entered into a financial transaction with the gallery owner Julien Levy for what amounted to a half interest in her collection. For her share of Atget's prints and negatives that she had saved from oblivion she received from the Museum of Modern Art $25,000, a little more than $3 a print. Today, the prices for select individual photographs later deaccessioned by the museum are nearing the sixty thousand dollar mark. Talking about the pictures Atget sold during his lifetime, Abbott once remarked: "The price of his photographs was indicative of the value placed on photographs by this French clientele. Masterpieces of photography sold for pennies. The prices ranged from .25 to 1.25 francs in 1911." A terrible irony connects these two artists—they received virtually no financial rewards for their work during their lifetime, yet artistic immortality has touched them both.

I think it was Abbott who best defined Atget's great achievement. She described Goethe's fascination with the pinnacle of artistic accomplishment as "an imagination for reality." This is perhaps the only description that does justice to Atget's vision—he had an imagination for reality.

It is utterly impossible for the modern viewer to look at Atget's Paris without feeling nostalgic for what we have lost. The new city of Paris that now encircles the landscape of Atget's pictures is often an exercise in soulless scale with flat, vertical concrete planes and easily aged glass walls that leak. It is a world of temporary workmanship. Today's Paris, like most cities in the world, suffers from architectural blight and a mirror-like sameness—like international airports set in the landscape of nowhere. In the gigantism of a machine-produced world, what we have lost is a human scale in our cities.

In Atget's images we can marvel at Paris, frozen forever at the moment of *la belle epoch*. In his remarkable rephotography project Christopher Rauschenberg's absolute passion for the work of Atget is clear. With unfailing patience and meticulous craftsmanship he has rediscovered the world of Atget's *ancien régime*. His accomplishment is almost archaeological in its intent. Moving a few trash baskets aside and waiting for cars to leave, he shows us in his images that Atget's Paris is in front of us still. Rauschenberg's photographs document the unique beauty of this great city, its heart still pulsing underneath the layers of indifferent con-temporary architecture.

Reconsidering Atget

Alison Nordstrom

Rephotography is a practice inherent in the nature of its medium. The camera's almost magical ability to freeze and isolate time and space manifests the specificity of moments and particular places. As we cannot in real life, we hold these visions in our hands and at our leisure. The photograph permits detailed observation, contemplation, and comparison: we can know the subjects it traces and transforms. This knowledge, and the way it shapes our ongoing looking, has moved innumerable photographers to capture subsequent parallel moments, sometimes in an attempt to replicate, sometimes to document change, and sometimes to celebrate, better understand, and appreciate other, earlier eyes.

Eugène Atget and Christopher Rauschenberg were born nearly one hundred years apart, in 1857 and 1951 respectively. The nineteenth-century man came to Paris as it rushed precipitously from its lingering trace of the ancient to take its place as a modern European capital. His photographs were deliberate attempts to preserve the old before its apparently inevitable disappearance; his venerable faces, rude cobbles, and mysterious doors and stairways take on particular poignancy. The occasional flashes of elongated blurred light in his images—in actuality a subject in motion too fast for accurate capture by Atget's slow shutter—feel like brash harbingers of the future intruding on the brooking silence of the past. In contrast, Rauschenberg came to Paris seeking to identify and preserve, not only some vision of premodern Paris, but the very premodern Paris that Atget himself had established and created photographically, with all its emotional qualities.

The varied practices of rephotography defy precise definition, though we understand that more elements are involved than a simple re-rendering of something photographed before. Thus, the ubiquitous images of the Egyptian pyramids, though popular to this day, should not usually be understood as a reference to the Zangaki Brothers or Francis Frith. They are simply an ongoing manifestation of a persistent visual icon and marker of place. It is unlikely that later photographers of Egypt, whether amateur or professional, studied the works of their forebears with the intention of commenting on them. Though making pictures of what has already been photographically portrayed has been common since the process was invented, intentional rephotographic projects are tellingly recent innovations. Their prevalence today points to the emergence of a full-fledged history of photography, the desire of artists to situate their work within the context of that history, and, perhaps, the ascendance of the notion that photographs work best as conceptual projects.

While Milton Rogovin's depiction of families in Buffalo, New York and Nicholas Nixon's ongoing thirty-year study of his wife and her sisters, remind us that the subjects of these temporal taxonomies may be human, and painfully mortal at that, recent rephotographic projects are most commonly associated with place. Many of the best known of these are feats of technical precisions and historical explication. Douglas Levere, for example, began a project in 1997 that replicated Berenice Abbott's 1939 survey, *Changing New York*. Levere revisited Abbott's original sites at the exact times of day and year that the original photographs were captured, strictly replicating Abbott's camera angles and depth of field. In his search for veracity, he even employed the very camera Abbott had used. The result was more than one hundred pairs of "then and now" images that stand as a record of architectural and technological change, and encourage meticulous back-and-forth comparisons of the visual information they contain. "A single photograph gives the illusion that time stops. A rephotograph lifts that illusion," asserts Levere. "In this tangle of old and new...lies the truth that Berenice Abbott understood well....Change is the only permanence."

Such flux is also the emphasis of Matthew Buckingham's 2005 study *One Side of Broadway,* an homage to Rudolph De Leeuw's 1910 survey *Both Sides of Broadway,* which documented every building on that famed New York City thoroughfare between Bowling Green and Columbus Circle. Presented as a slide installation, Buckingham's visual index is also a vehicle for the presentation of historical factoids, as a voice-over notes the events and activities that occurred in the buildings, with emphasis on early photographic studios and cinemas. In a similar venture, Omar Khan's pioneering 1995 experiment in multimedia, *Through a Magic Lantern: Jackson's India, 1895,* uses interactive digital technologies to meld William Henry Jackson's photochromes and lantern slides of a thousand-mile rail journey through South Asia with Khan's own replication of them made one hundred years later.

Perhaps the most well-known and complex rephotographic surveys undertaken in the last decades are the Second View and Third View projects led by Mark Klett in the 1970s and again in the late 1990s. These projects were based on the western geological survey images of William Bell, John K. Hilliers, William Henry Jackson, and Timothy O'Sullivan, which had been made immediately after the Civil War, and were, in most cases, the earliest images ever taken of that part of the world. In both Second View and Third View, Klett and his teams made multiple images at the site of each historical photograph with an eye to precise imitation. Vantage points, weather conditions, lighting, and seasons were replicated as exactly as possible. The original photographs stand as a baseline against which subsequent change can be visualized and evaluated. The second views, made more than a century later, dramatize this change; but, significantly, the third views, made in most cases only twenty years after the second, reveal the most dramatic transformations

Most of the rephotographic projects considered here call attention to change, but Rauschenberg's treatment of Atget's Paris demonstrates that rephotography can also reveal the persistence and consistency of certain visual themes. Rauschenberg has chosen not to replicate Atget's equipment, stance, or time of day. Rather, his images are a reference to the distinctive mood and characteristics of the earlier photographs. In some, it is a familiar and singular object, such as a dress-shaped hanging sign, that marks a site as reminiscent of Atget. In others, it is an almost ineffable emotional nuance that evokes the already-seen in similar doorways and staircases to those Atget knew.

The invention of the camera has changed not only how and what we see, but how and what we remember. Rauschenberg was seventeen when he first saw Paris, but he was already a photographer and already familiar with Atget's work. In creating this homage to his distinguished predecessor, he has given us both another frozen moment in the flux of a vital city and a comment on the photographs as history and art.

Plates

Arrondissements 1, 2, 3 & 4

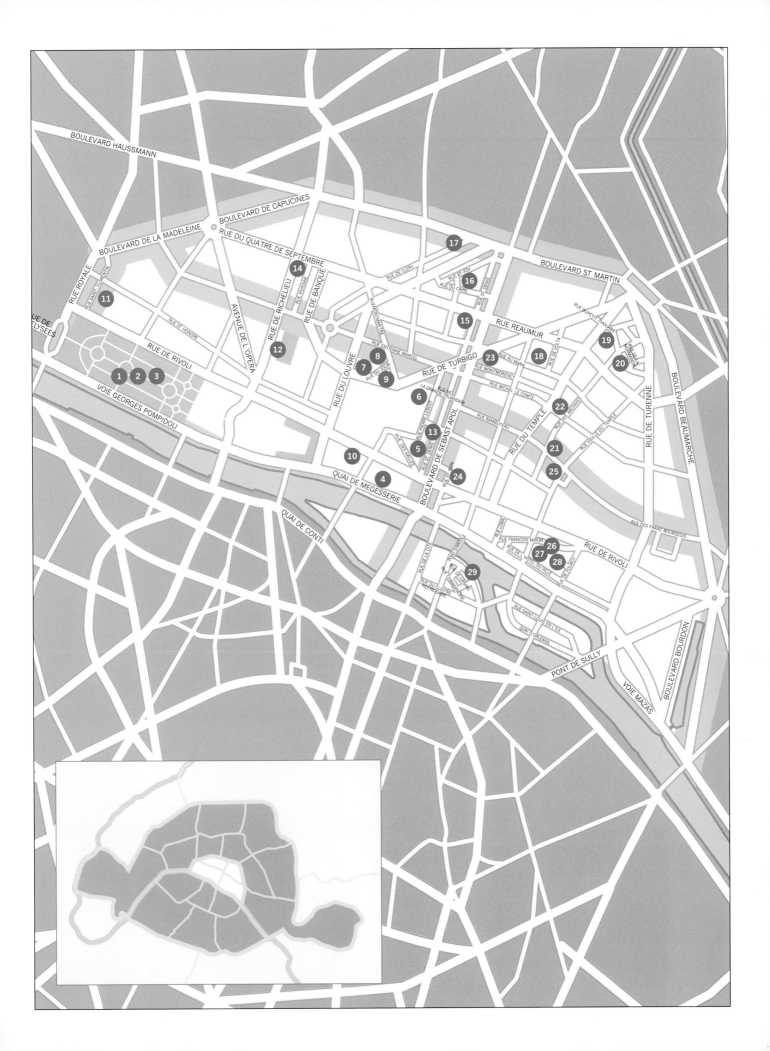

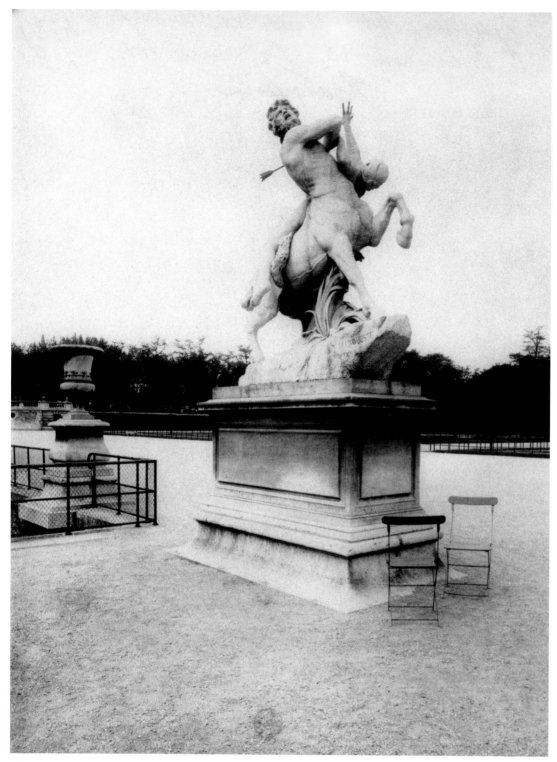

The Abduction of Déjanire, by Marqueste, jardin des Tuileries, 1907–08

The Abduction of Déjanire, by Marqueste, jardin des Tuileries, 1998

Jardin des Tuileries, 1907

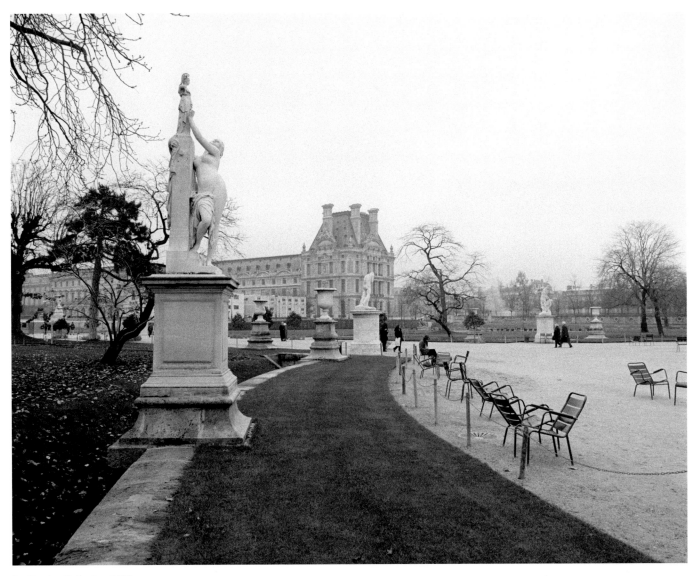

Jardin des Tuileries, 1998

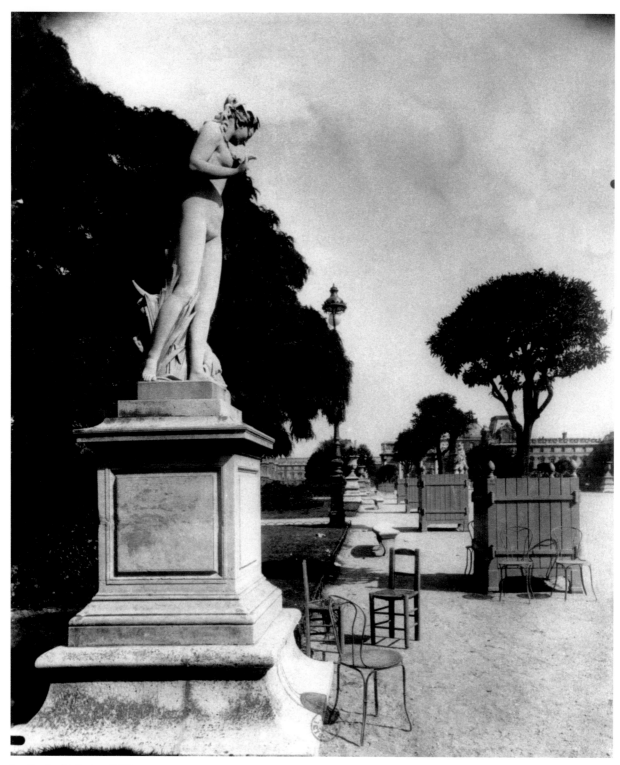

Jardin des Tuileries, 1907

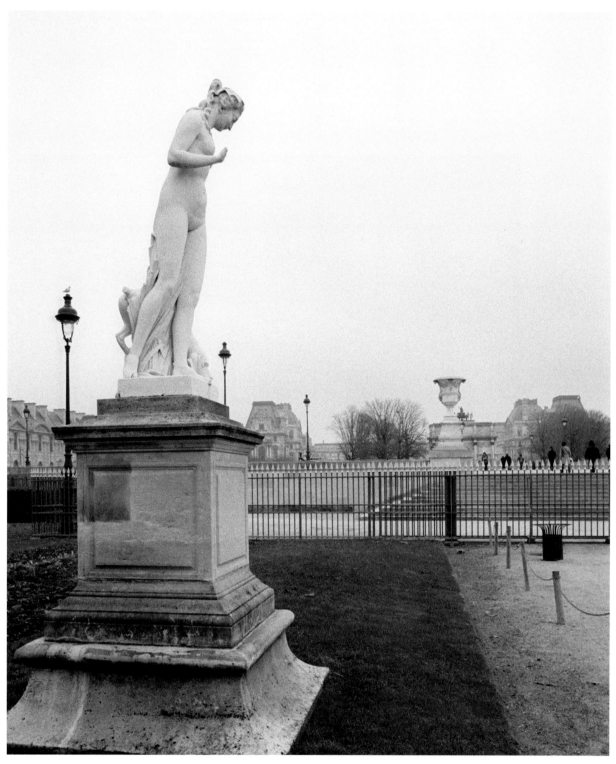

Jardin des Tuileries, 1998

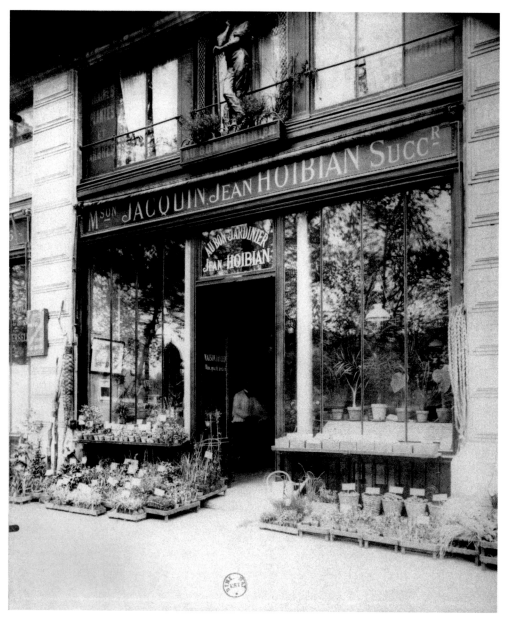

Au Bon Jardinier, quai de la Mégisserie, 1902

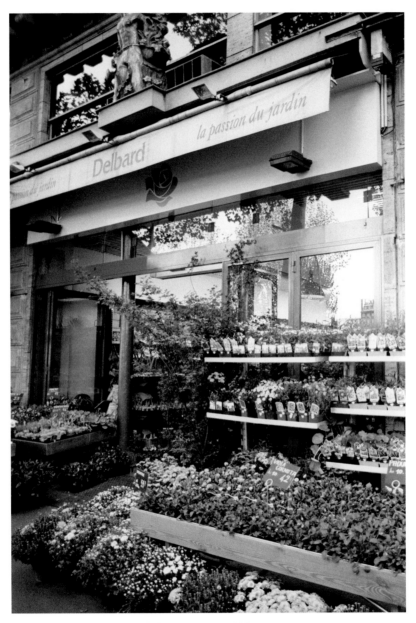

La Passion du Jardin, quai de la Mégisserie, 1997

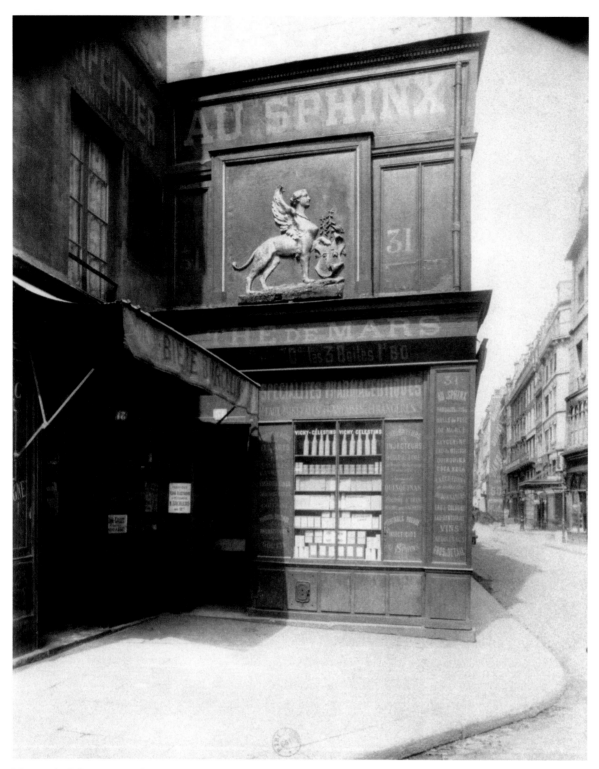

Maison du Sphinx, 31 rue Saint-Denis, 1907

31 rue Saint-Denis, 1997

Intersection of rue de la Grande-Truanderie and rue Pierre-Lescot, 1907

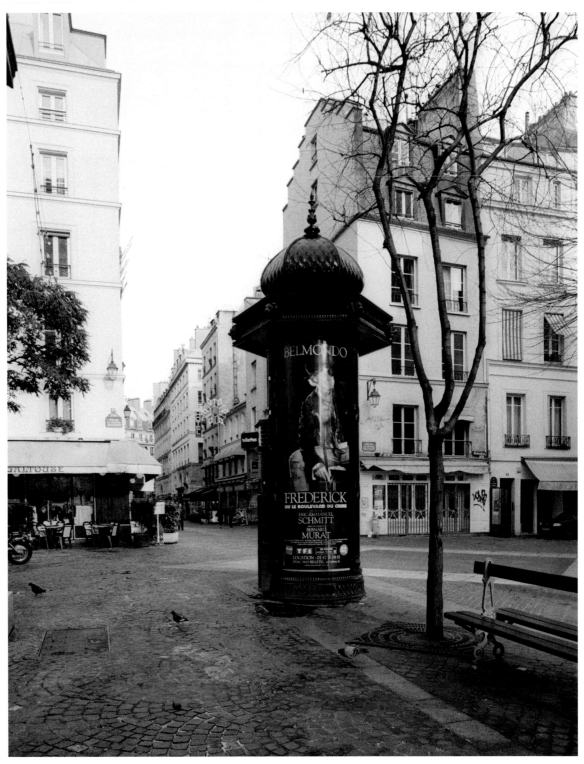

Intersection of rue de la Grande-Truanderie and rue Pierre-Lescot, 1998

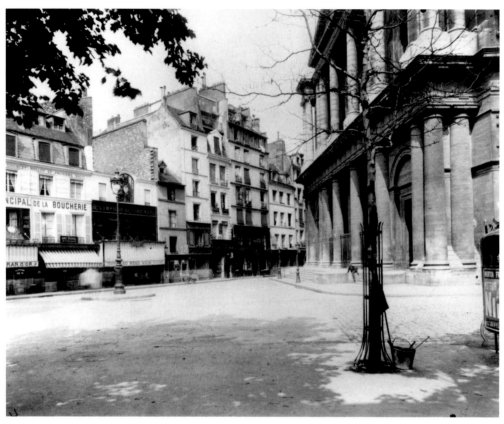

Saint-Eustache Church and rue du Jour, 1902

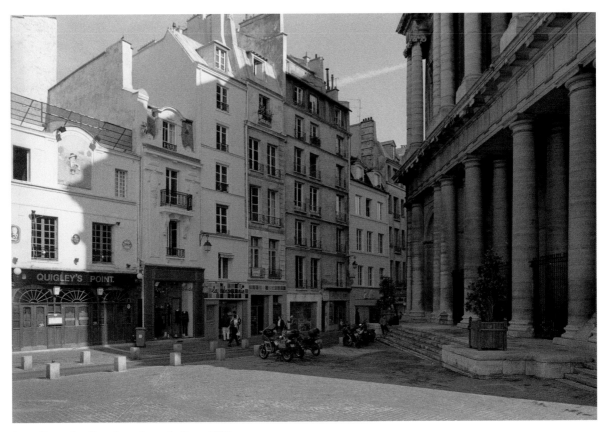

Saint-Eustache Church and rue du Jour, 1997

Former home of the choir school of Saint-Eustache Church, 25 rue du Jour, 1902

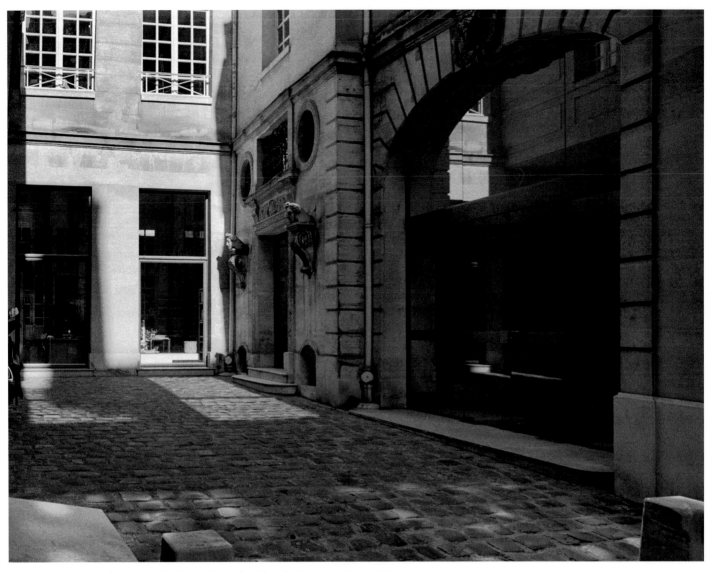

Former home of the choir school of Saint-Eustache Church, 25 rue du Jour, 1998

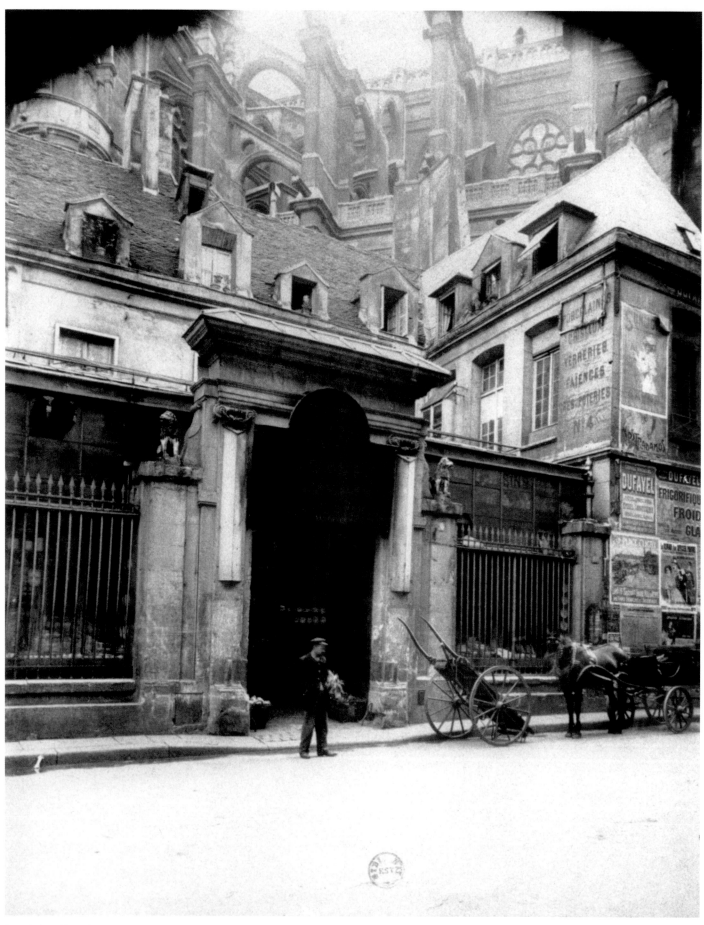

Hôtel des abbés de Royaumont, 4 rue du Jour, 1907

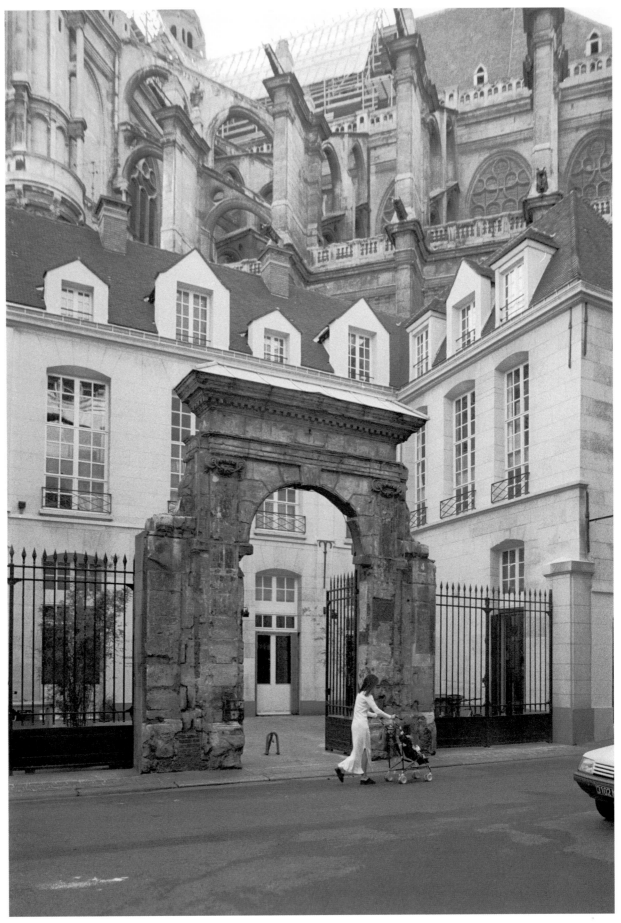

Hôtel des abbés de Royaumont, 4 rue du Jour, 1997

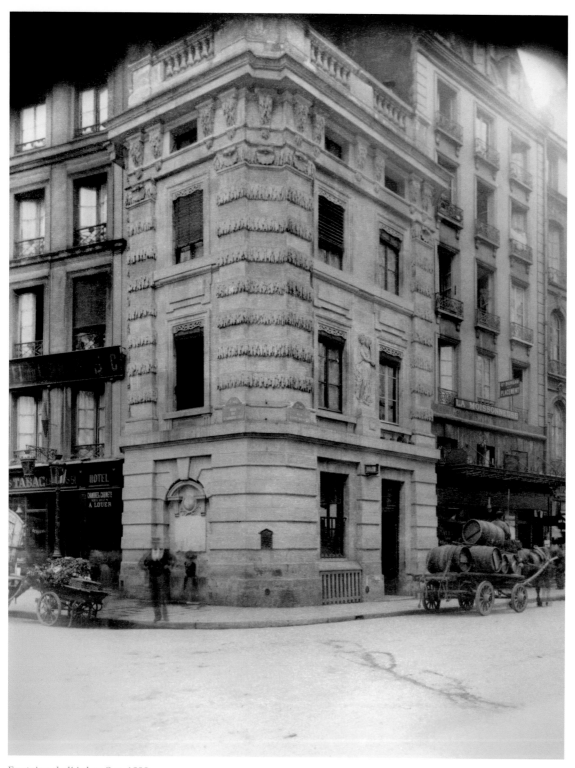

Fontaine de l'Arbre-Sec, 1899

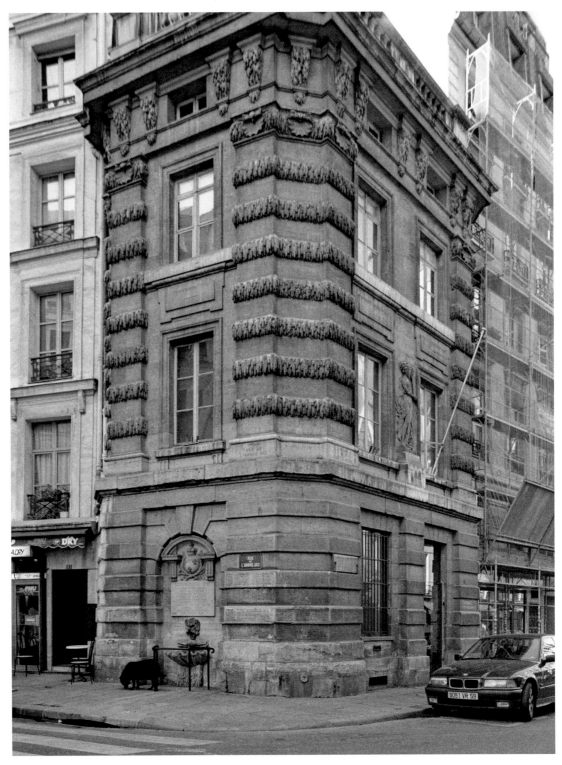

Fontaine de l'Arbre-Sec, 1997

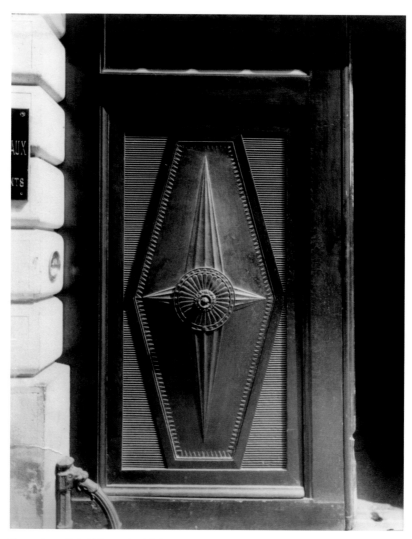

Door, 6 rue Saint-Florentin, 1912

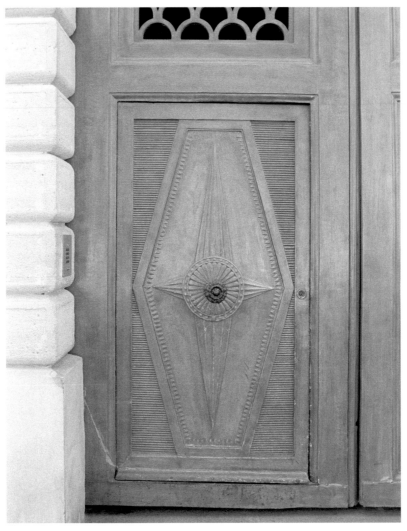

Door, 6 rue Saint-Florentin, 1998

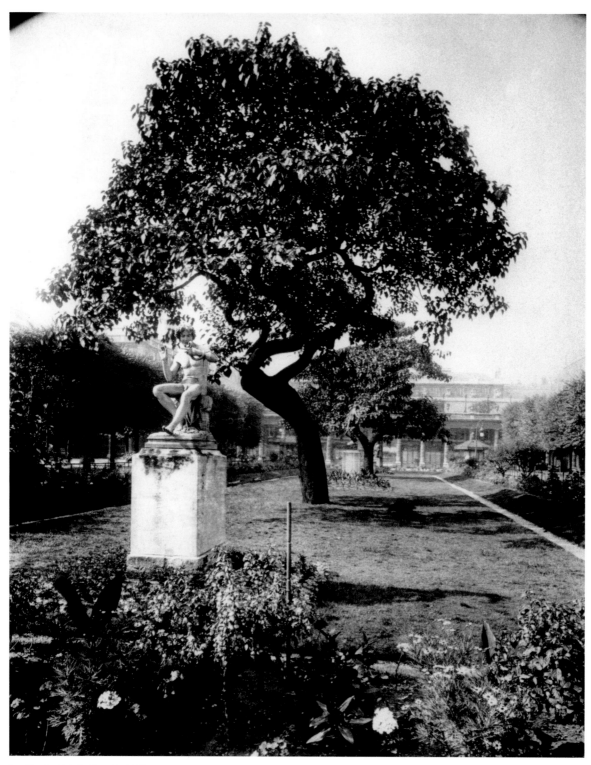

Jardin du Palais-Royal, 1905

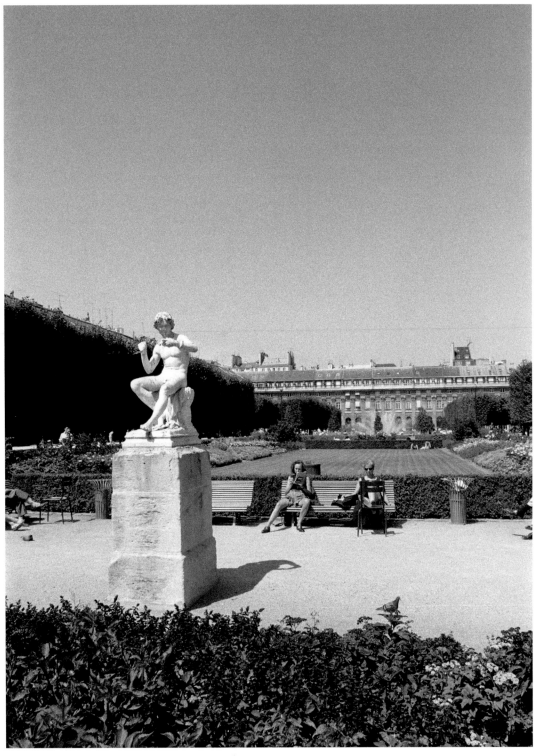

Jardin du Palais-Royal, 1998

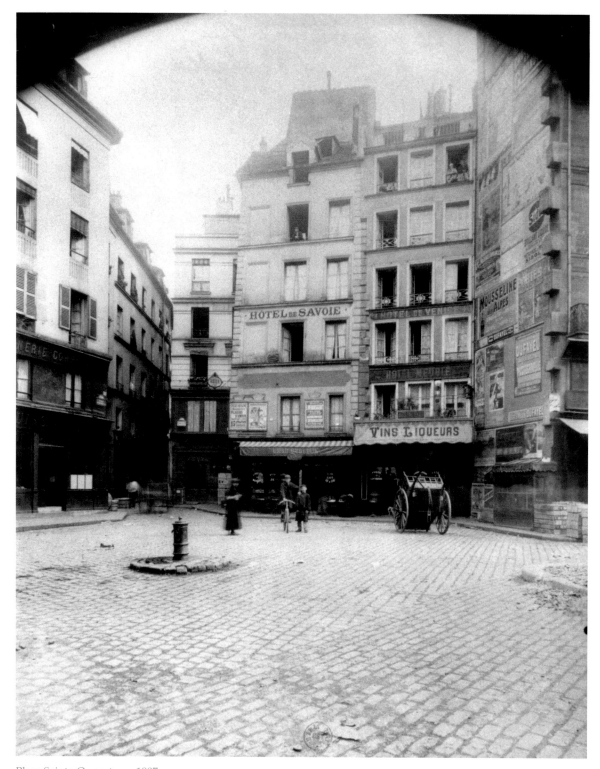

Place Sainte-Opportune, 1907

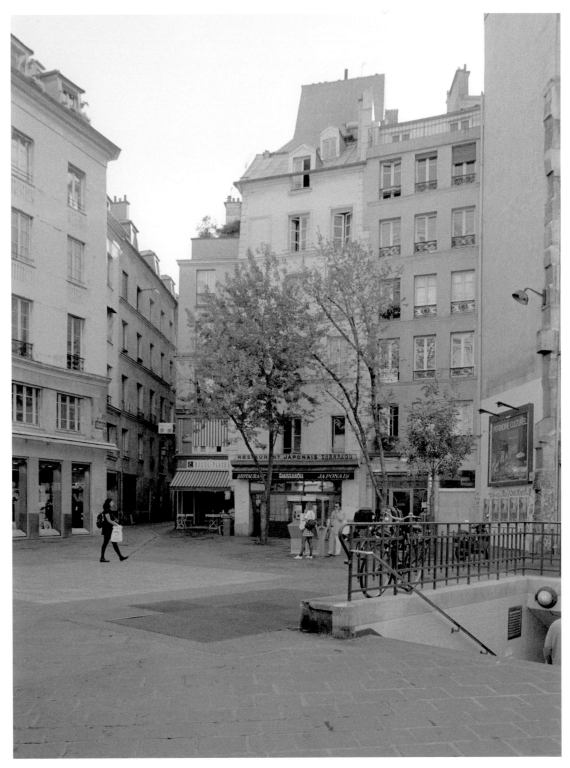

Place Sainte-Opportune, 1997

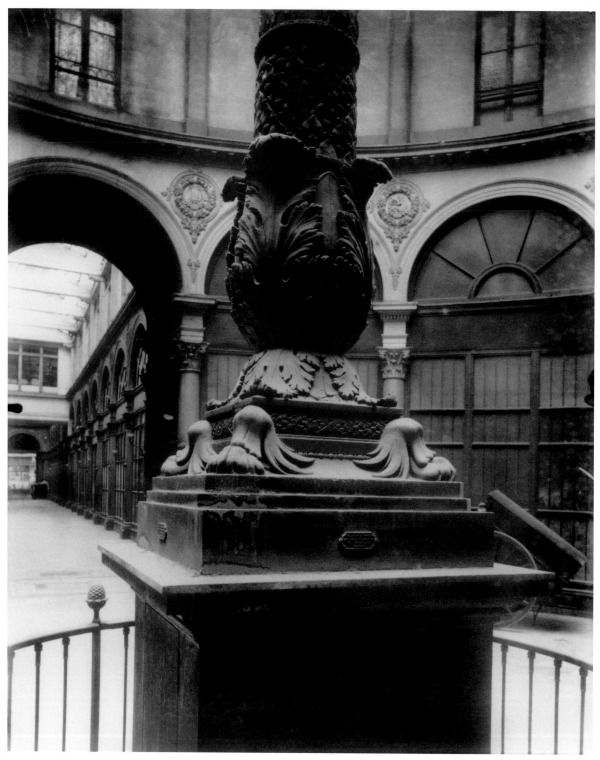

Galerie Colbert, rue Vivienne, 1906

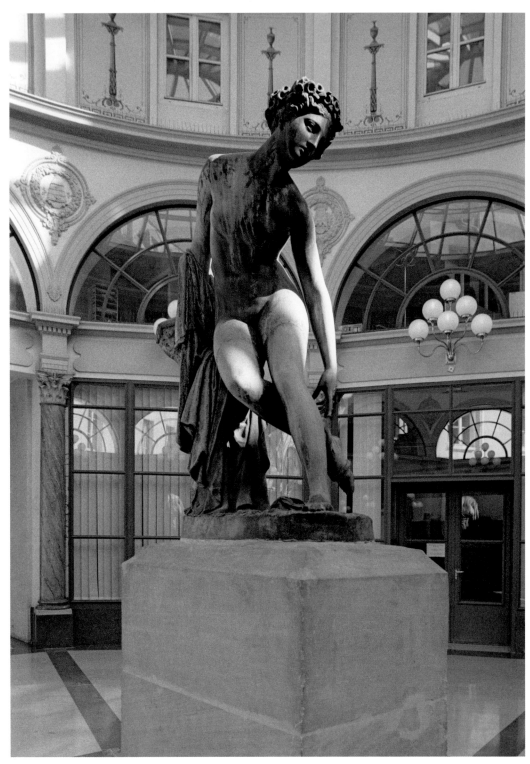

Galerie Colbert, rue Vivienne, 1997

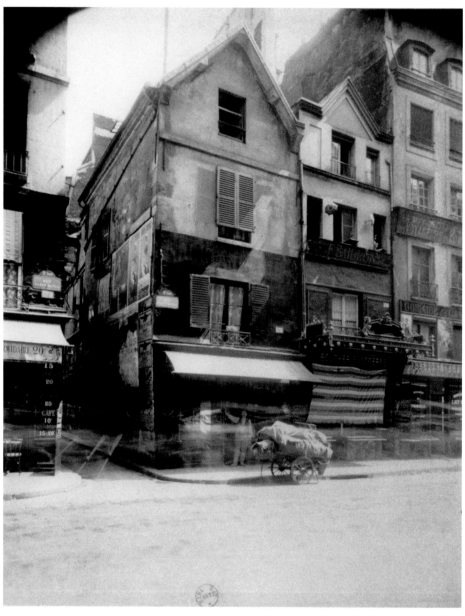

Corner of passage Basfour, 176 rue Saint-Denis, 1907

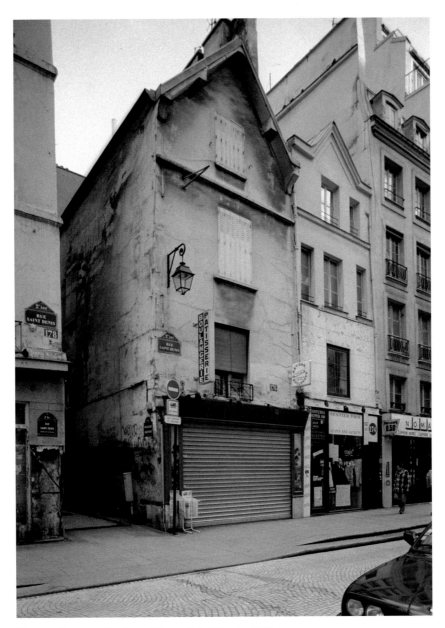

Corner of passage Basfour, 176 rue Saint-Denis, 1998

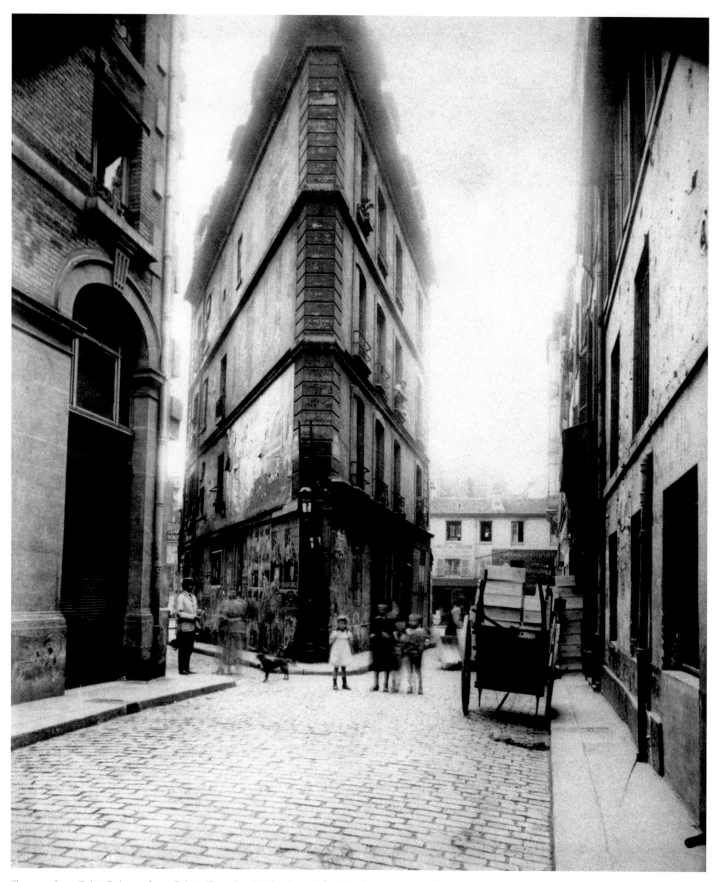

Corner of rue Saint-Spire and rue Sainte-Foy, about to be demolished for the extension of rue Dussoubs, 1907

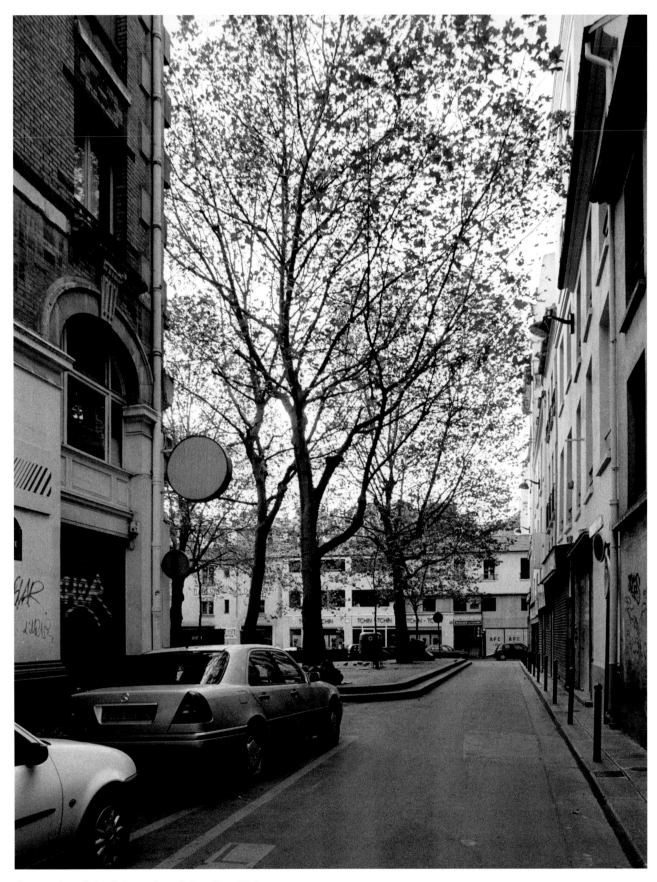

Corner of rue Saint-Spire and rue Sainte-Foy, 1998

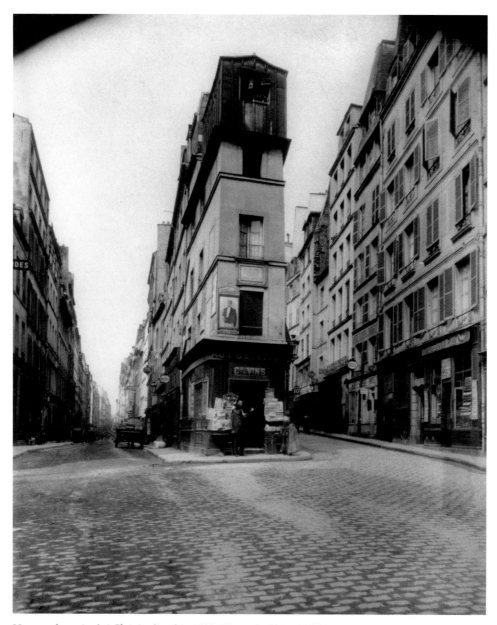

House where André Chénier lived in 1793, 97 rue de Cléry, 1907

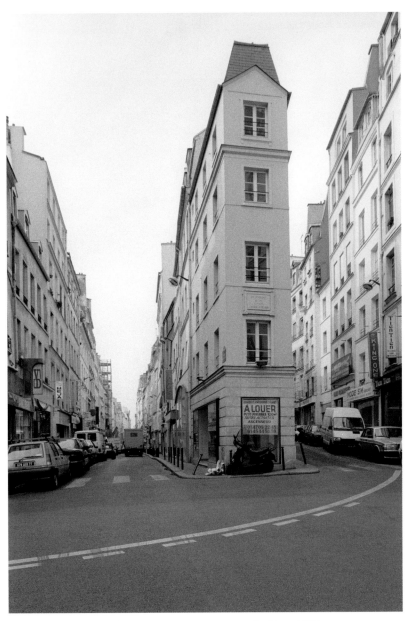

House where André Chénier lived in 1793, 97 rue de Cléry, 1997

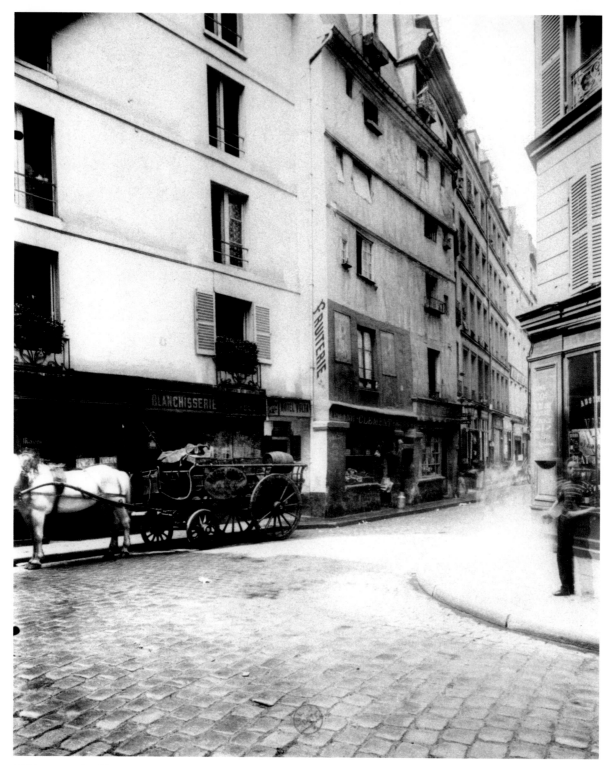

Old house and old boutique, 3 rue Volta, 1901

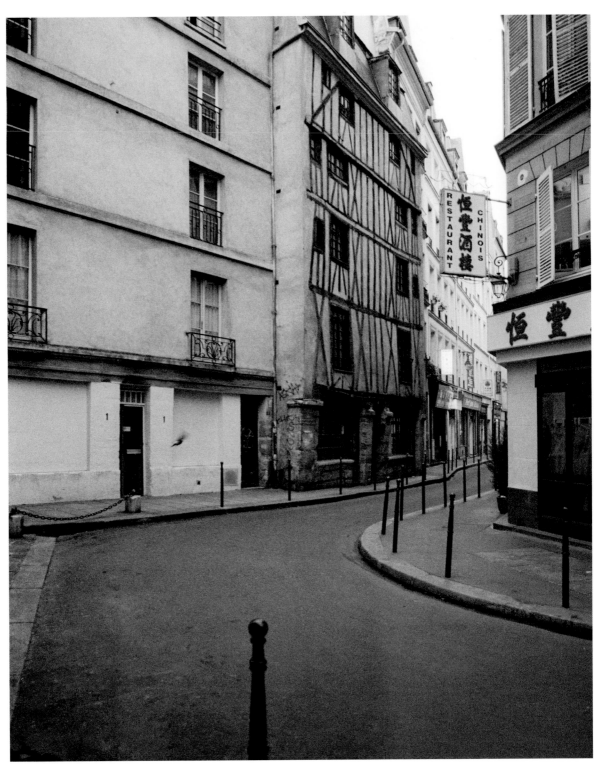

Old house, 3 rue Volta, 1998

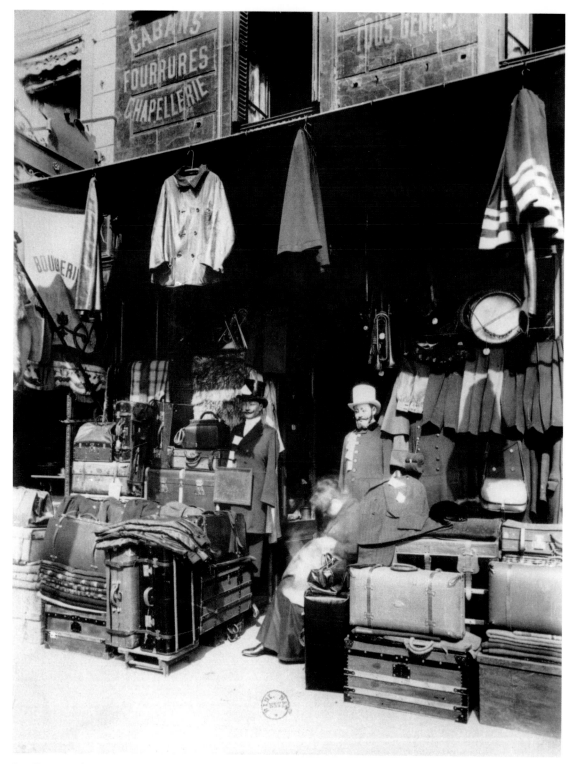

Rue Dupetit-Thouars, 1911

Rue Dupetit-Thouars, 1998

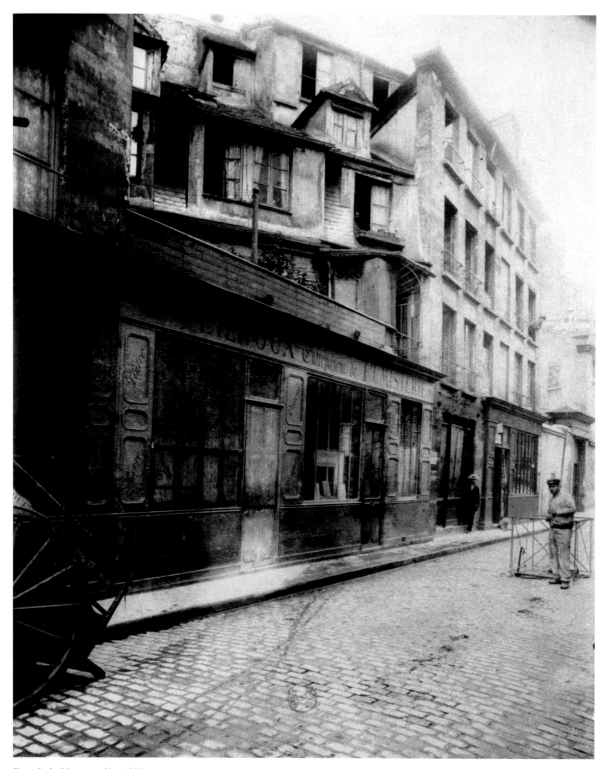

Rue de la Normandie, 1901

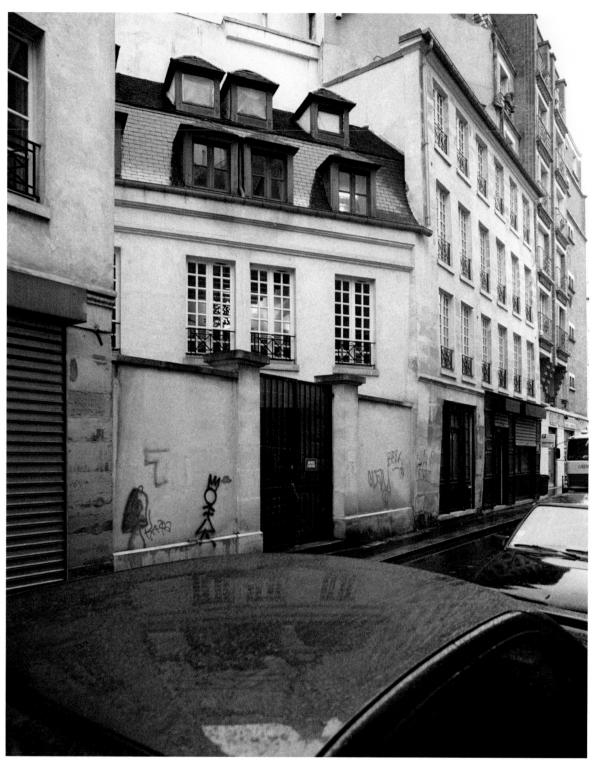

Rue de la Normandie, 1998

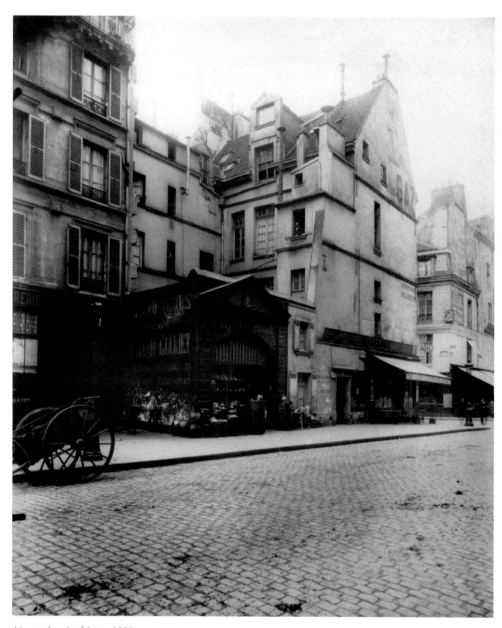

46 rue des Archives, 1901

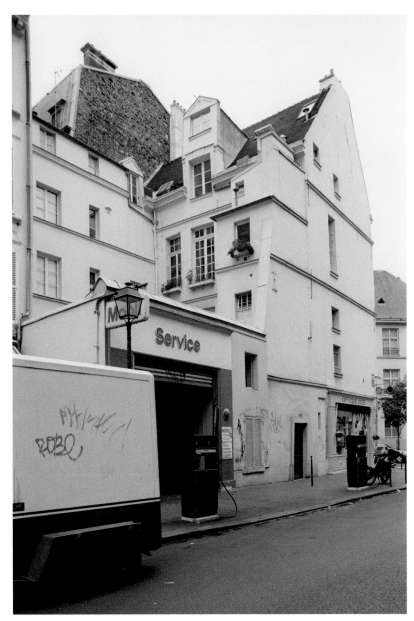

46 rue des Archives, 1997

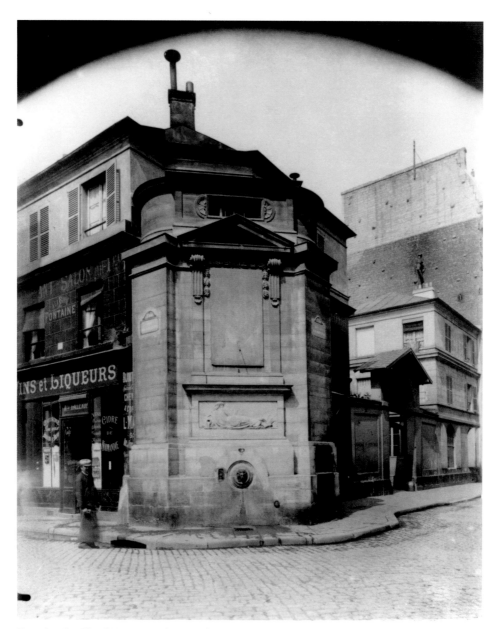

Fontaine des Haudriettes, rue des Haudriettes, 1898

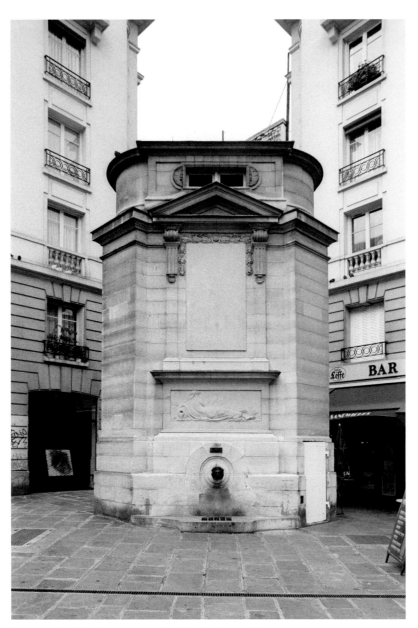

Fontaine des Haudriettes, rue des Haudriettes, 1997

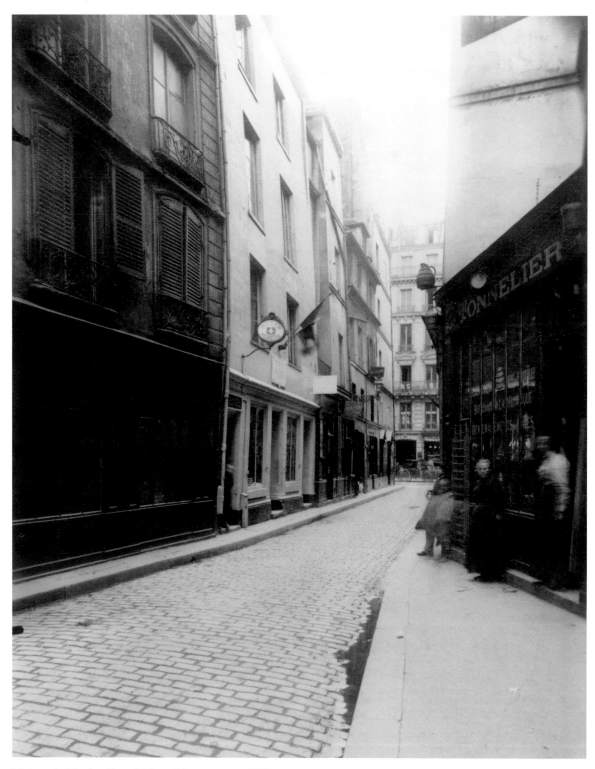

Maison de Nicolas Flamel, 51 rue Montmorency, 1902

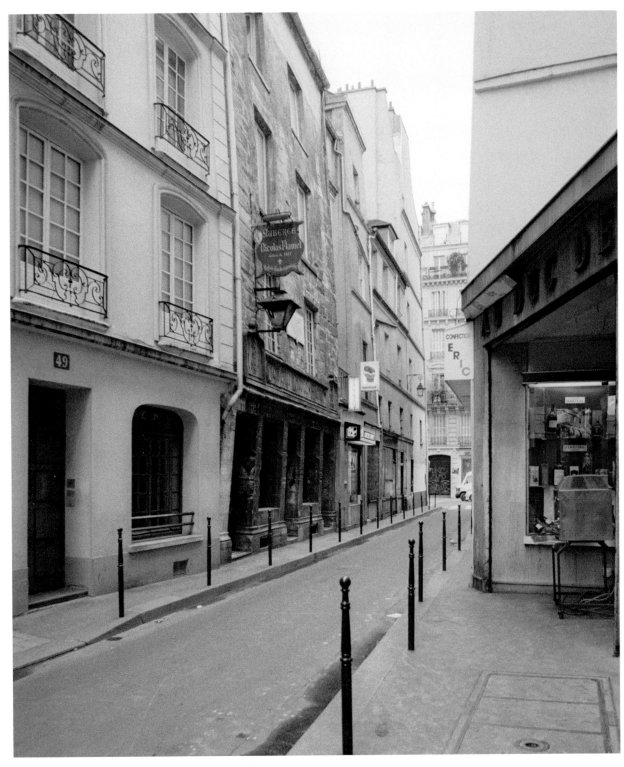

Maison de Nicolas Flamel, 51 rue Montmorency, 1998

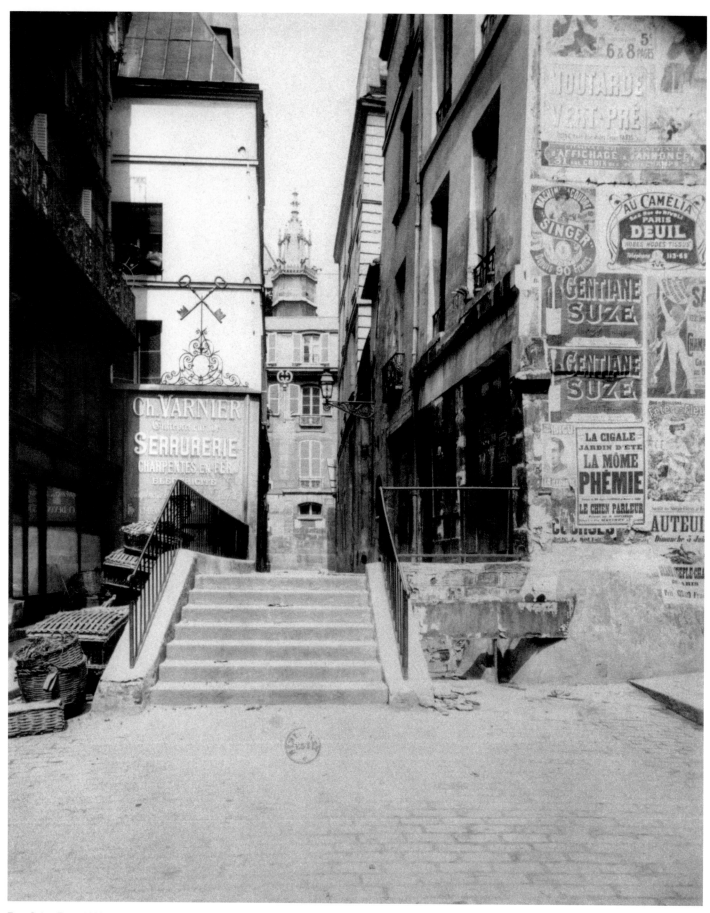

Rue Saint-Bon, 1903

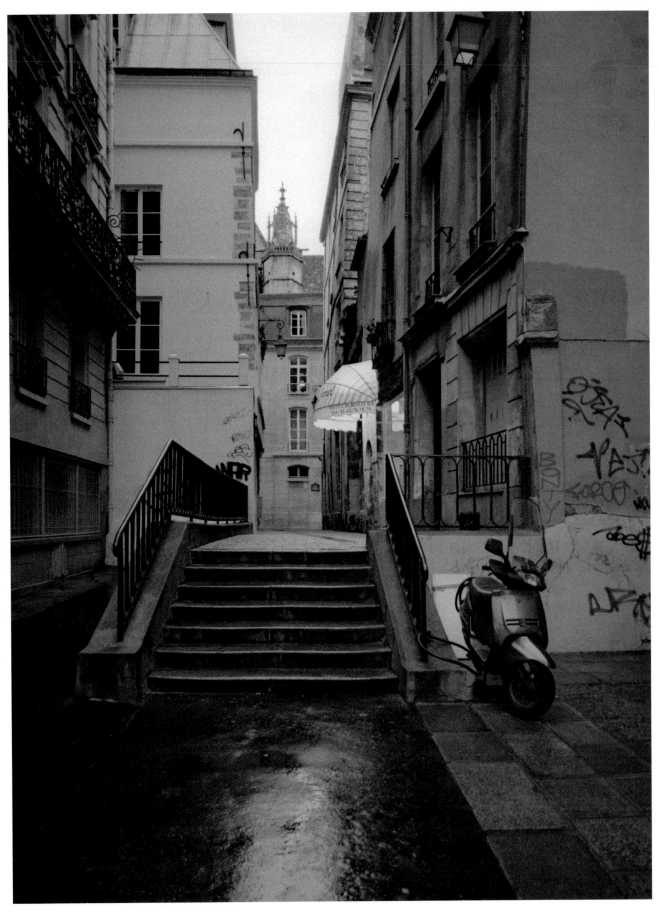

Rue Saint-Bon, 1998

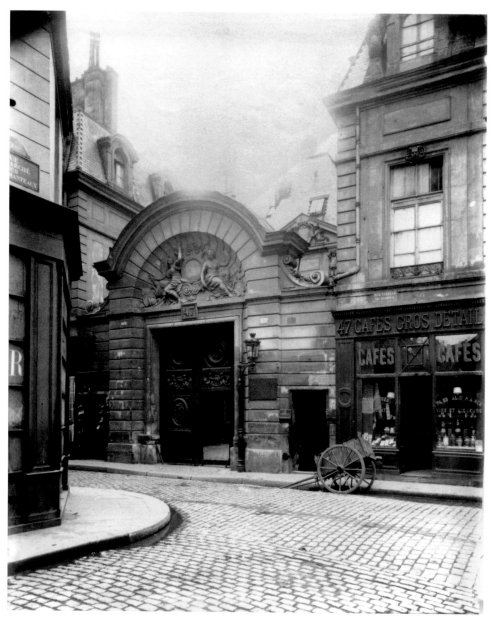

Hôtel des Ambassadeurs de Hollande, 47 rue Vieille-du-Temple, 1898

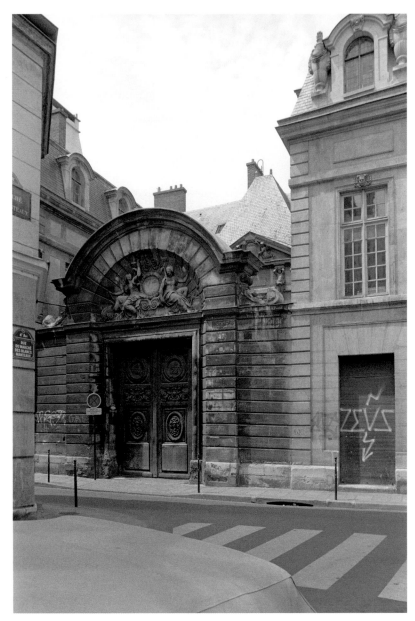

Hôtel des Ambassadeurs de Hollande, 47 rue Vieille-du-Temple, 1997

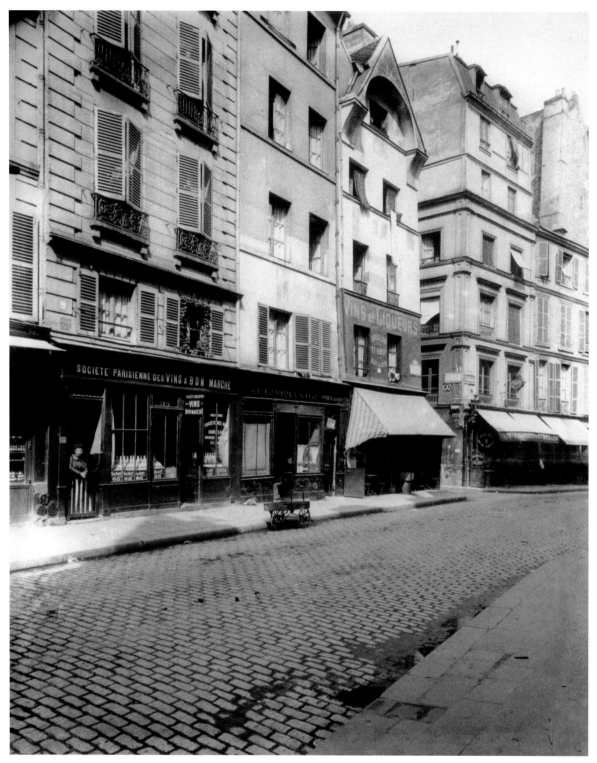

13 rue François-Miron, 1902

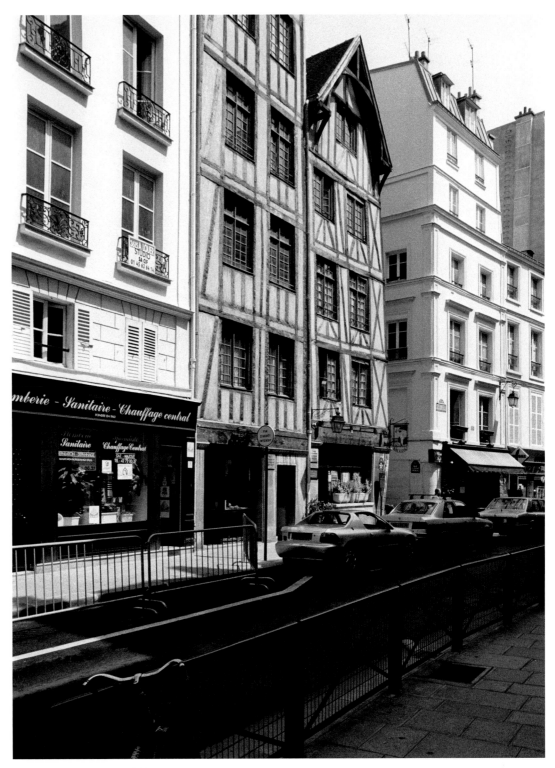

13 rue François-Miron, 1998

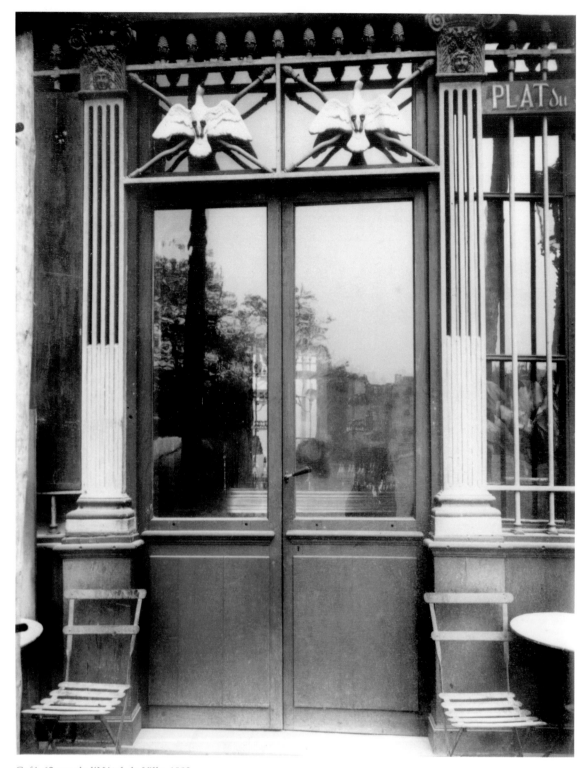

Café, 62 rue de l'Hôtel-de-Ville, 1903

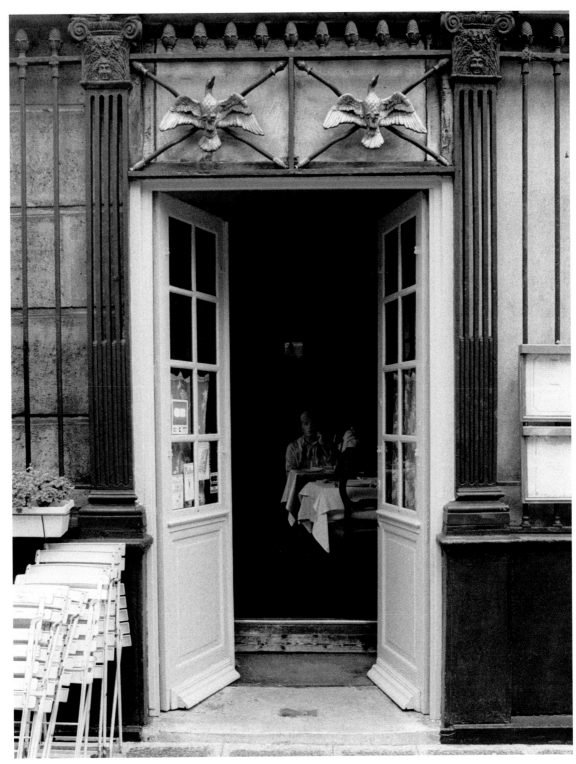

Café, 62 rue de l'Hôtel-de-Ville, 1997

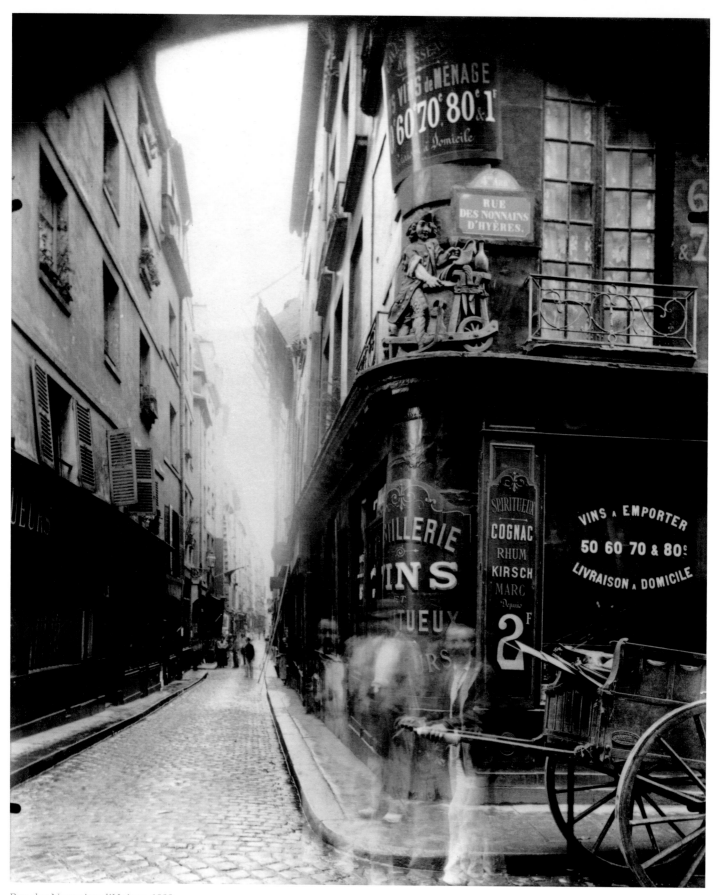

Rue des Nonnains-d'Hyères, 1900

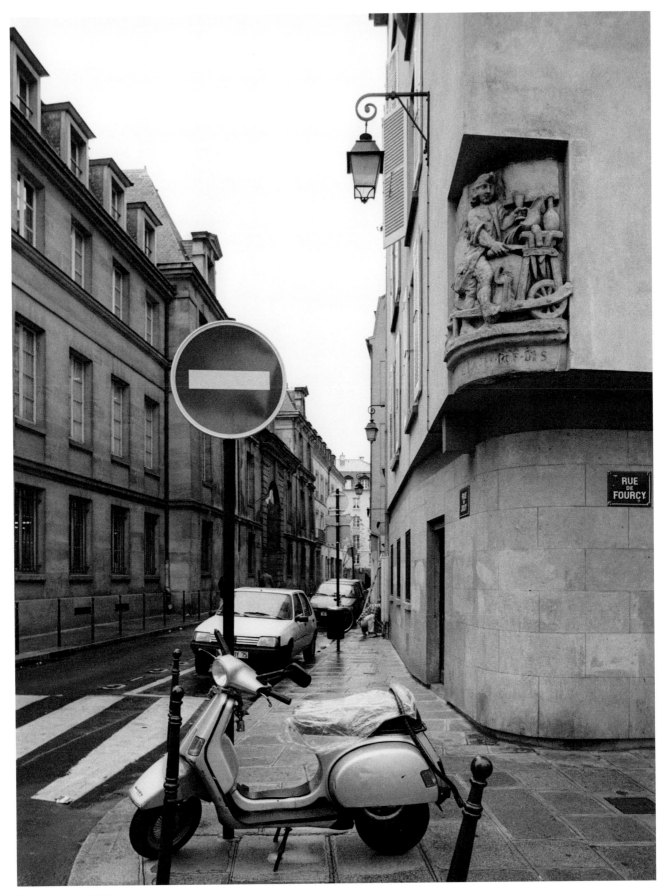

Rue de Fourcy, 1998

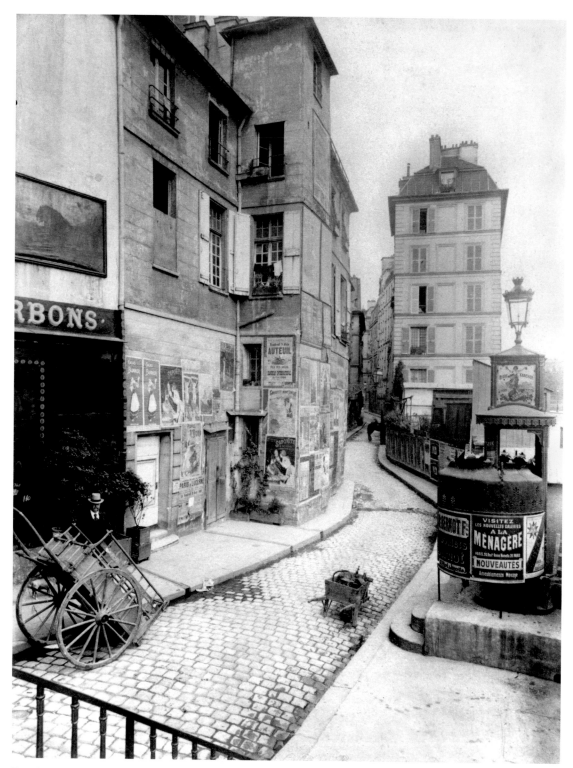

Rue des Ursins, 1900

Rue des Ursins, 1998

Arrondissements 5, 6 & 14

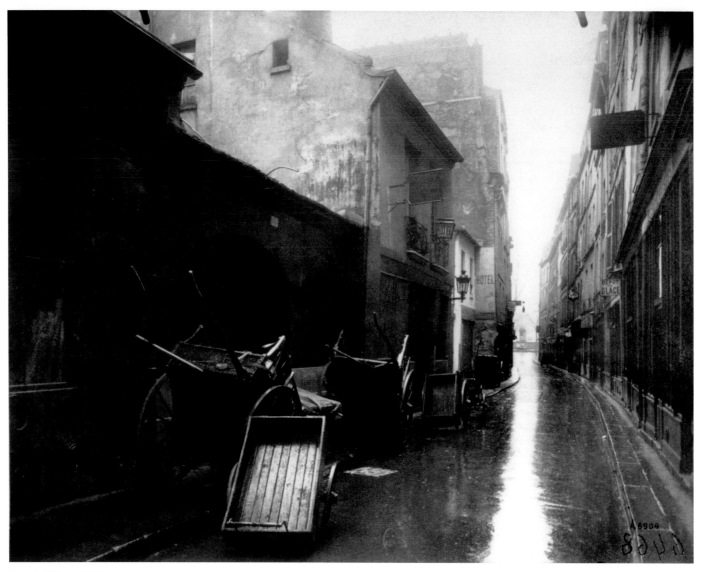

Rue de Bièvre, 1924

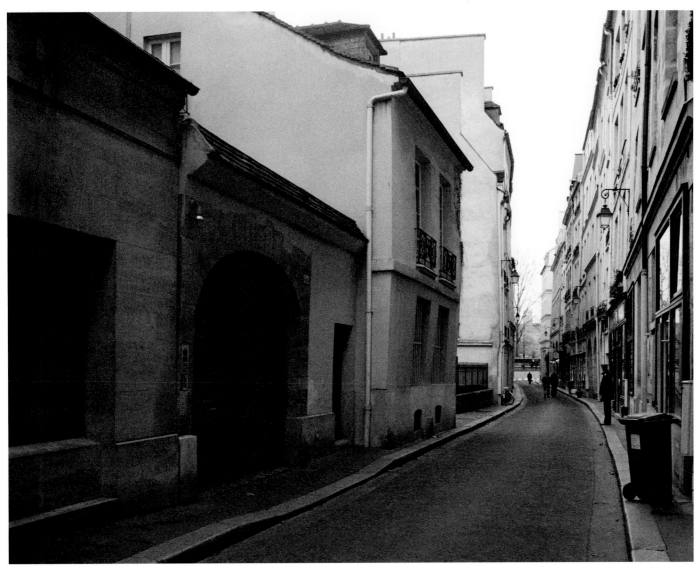

Rue de Bièvre, 1998

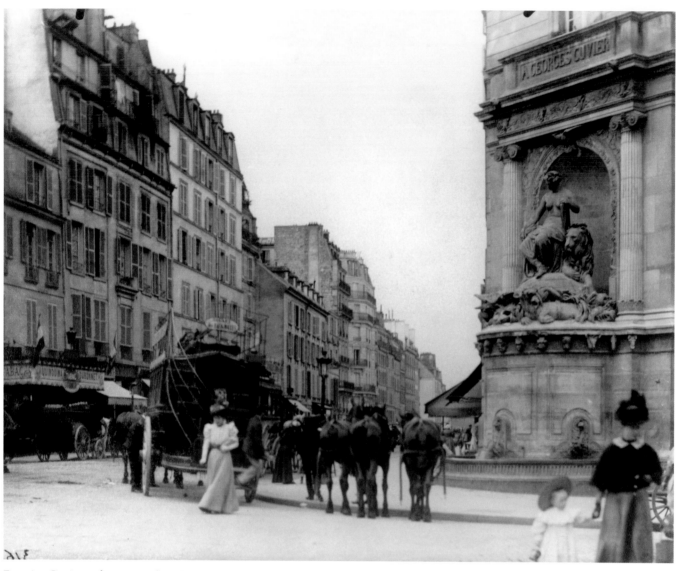

Fontaine Cuvier at the corner of rue Linné, 1899

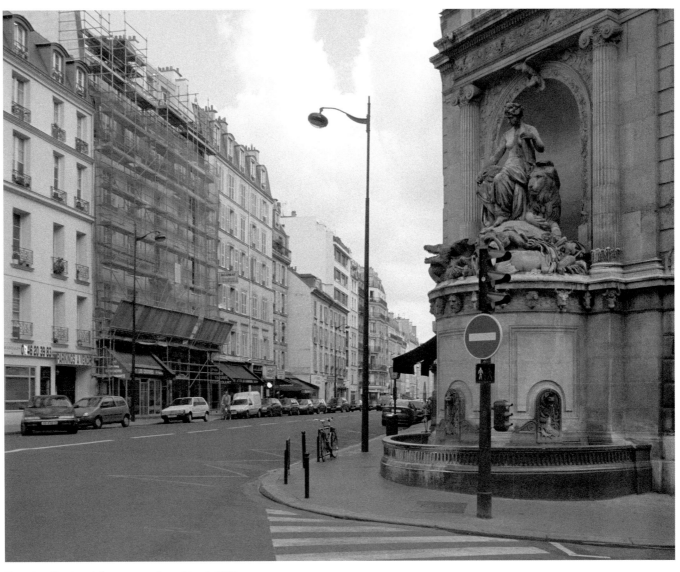

Fontaine Cuvier at the corner of rue Linné, 1998

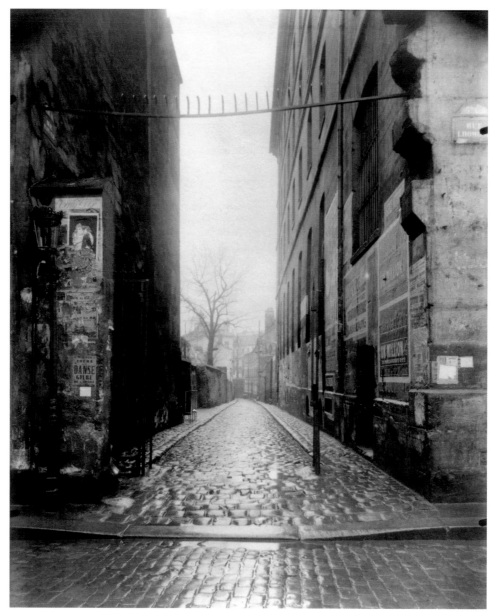

Intersection of rue Lhomond and rue Rataud, 1913

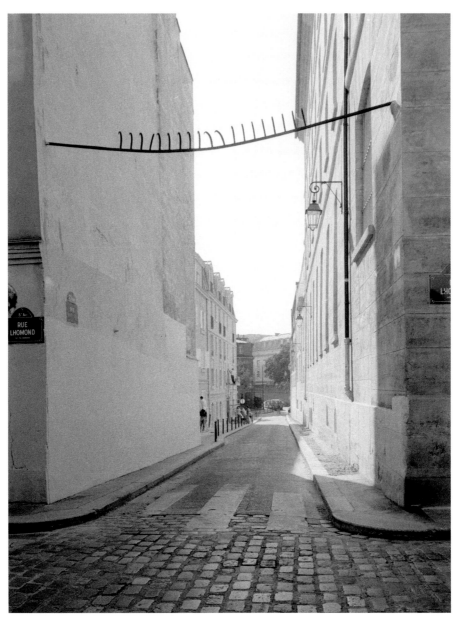

Intersection of rue Lhomond and rue Rataud, 1997

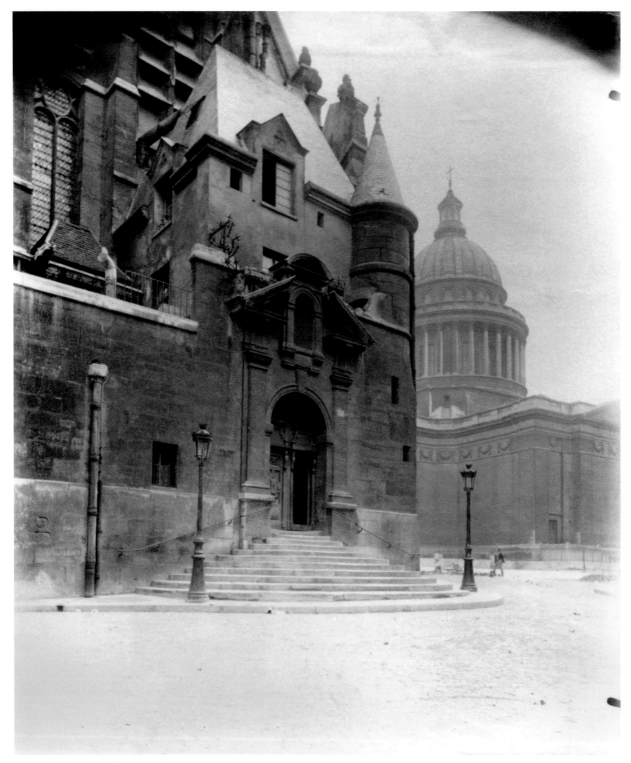

The church of Saint-Étienne-du-Mont, with the Panthéon in the background, 1898

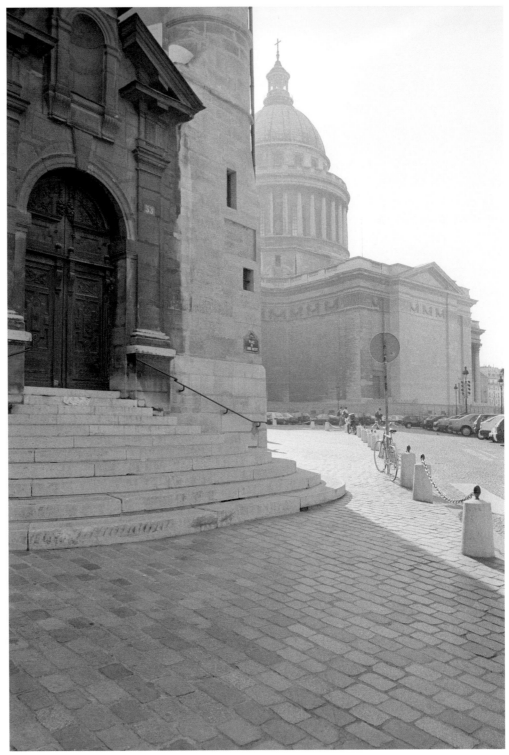

The church of Saint-Étienne-du-Mont, with the Panthéon in the background, 1997

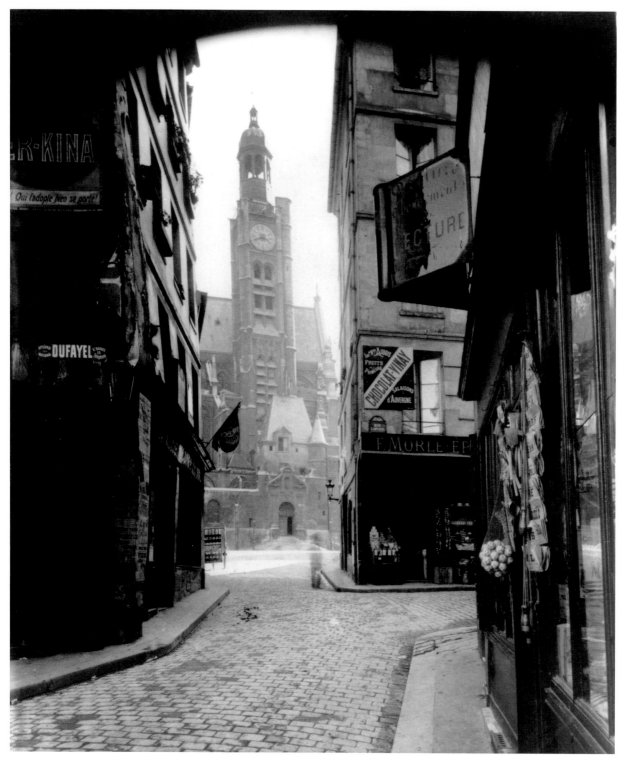

Intersection of rue Laplace and rue de la Montagne-Sainte-Geneviève, 1898

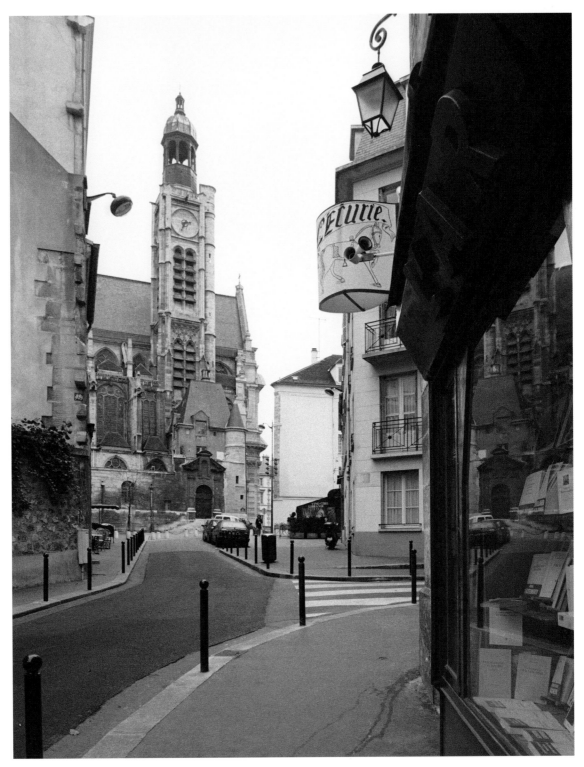

Intersection of rue Laplace and rue de la Montagne-Sainte-Geneviève, 1998

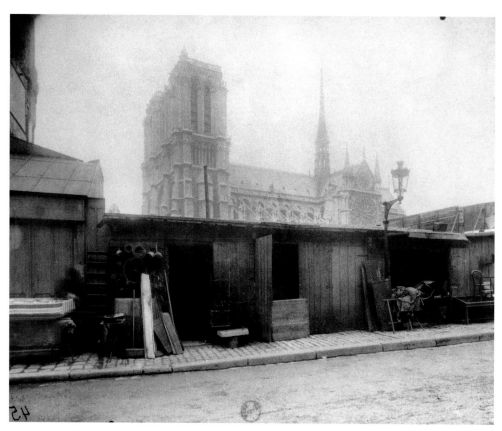

Rue de la Bûcherie, circa 1900

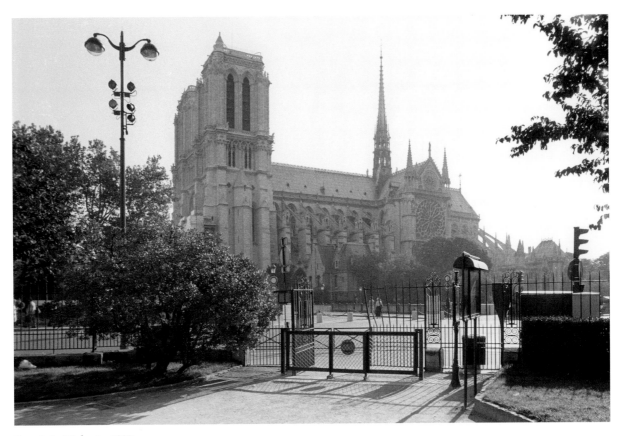

Rue de la Bûcherie, 1998

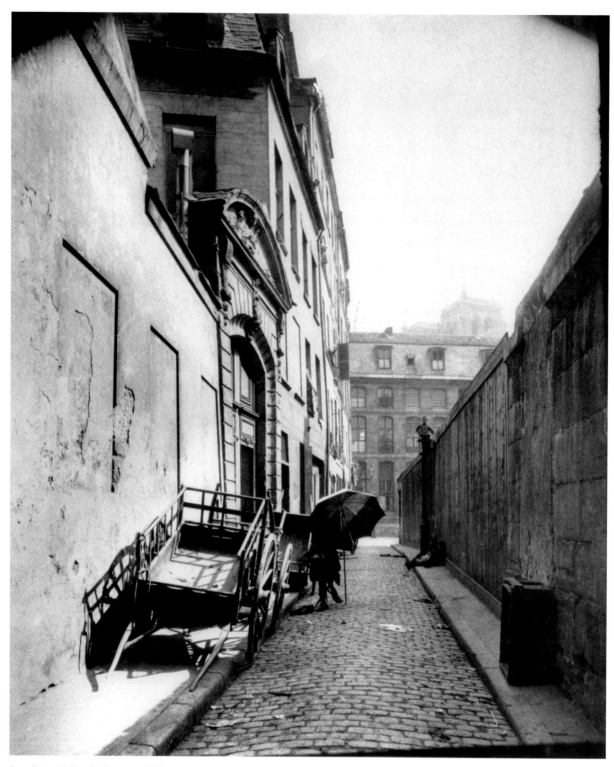

Rue Saint-Julien-le-Pauvre, 1898

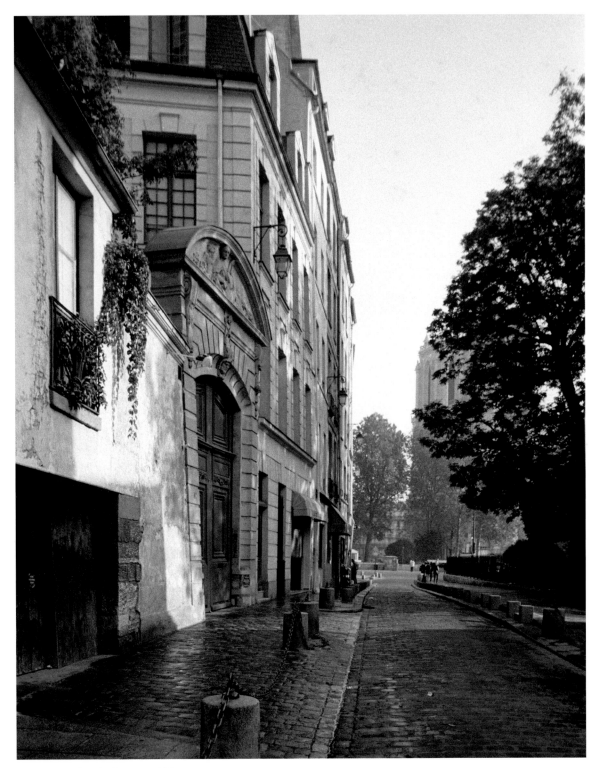

Rue Saint-Julien-le-Pauvre, 1997

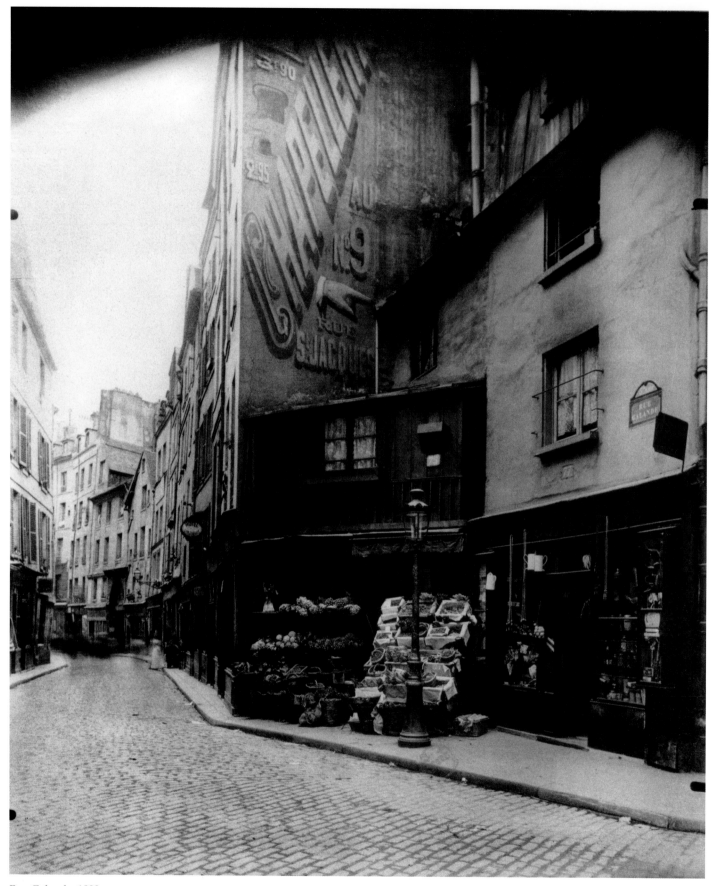

Rue Galande, 1899

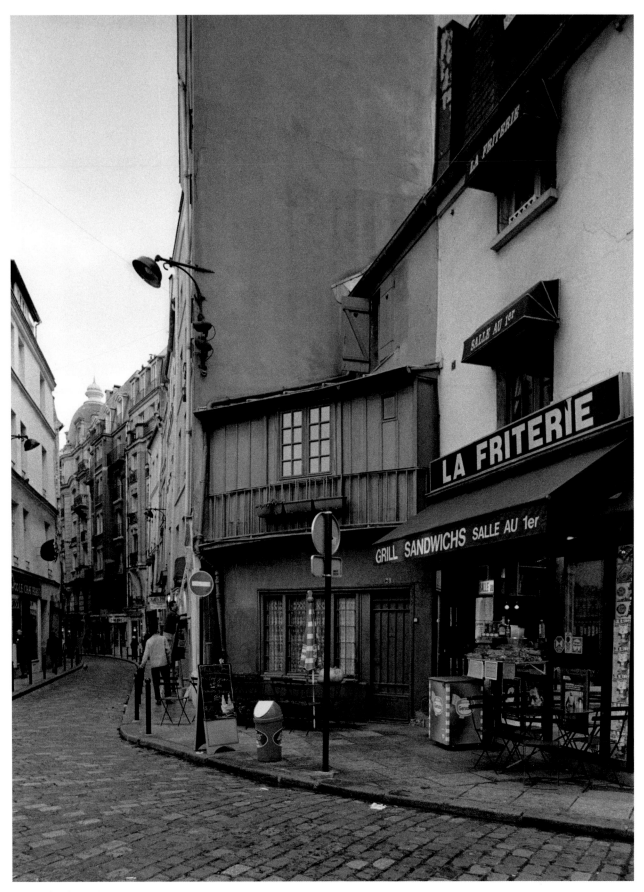

Rue Galande, 1998

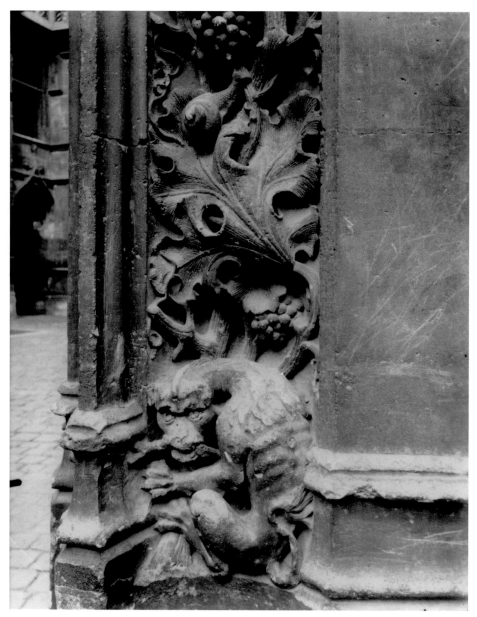

Cluny (door), 1902

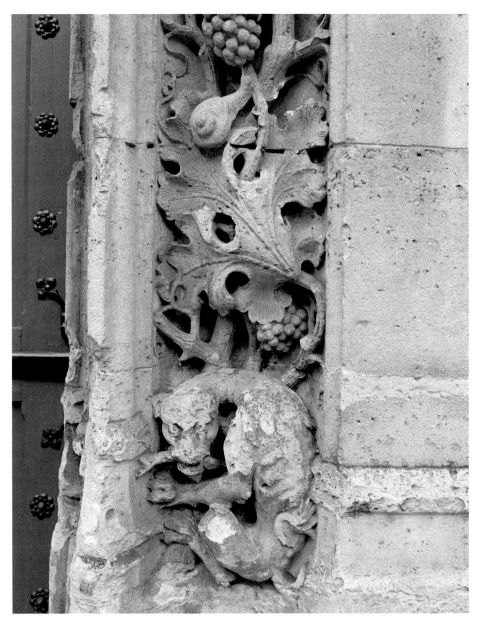

Cluny (door), 1998

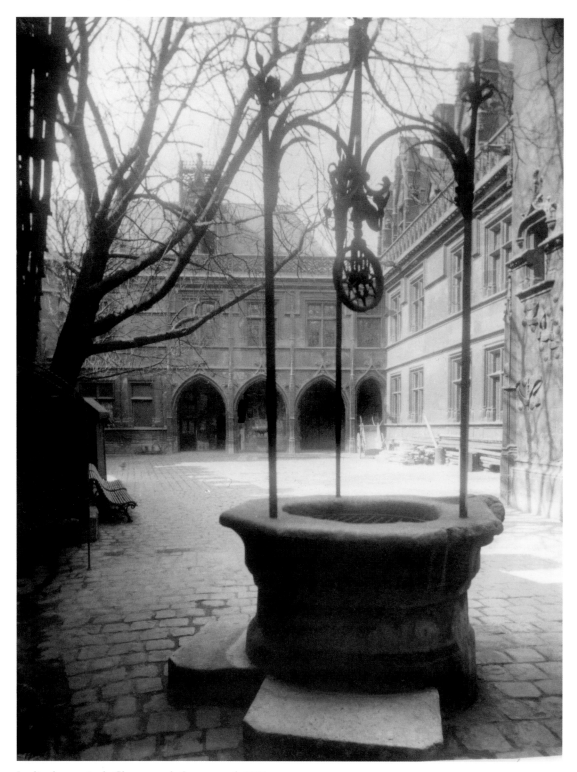

Jardin du musée de Cluny, rue de Sommerard, 1907

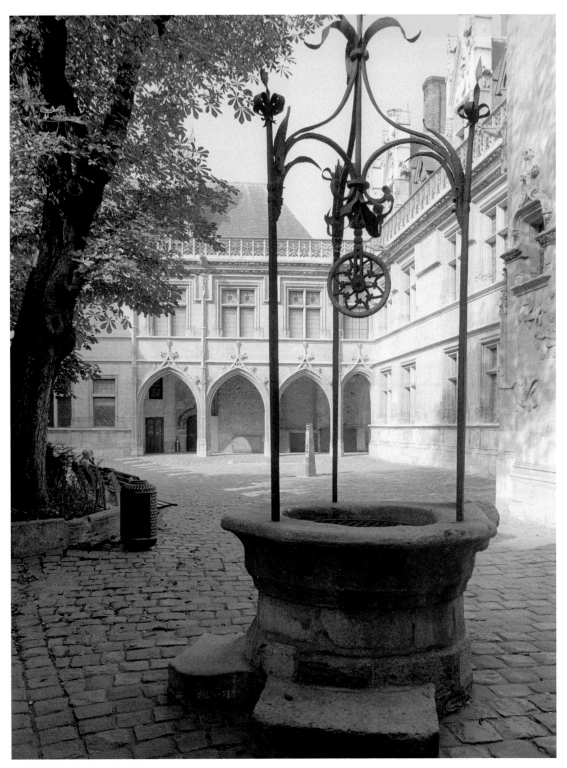

Jardin du musée de Cluny, rue de Sommerard, 1997

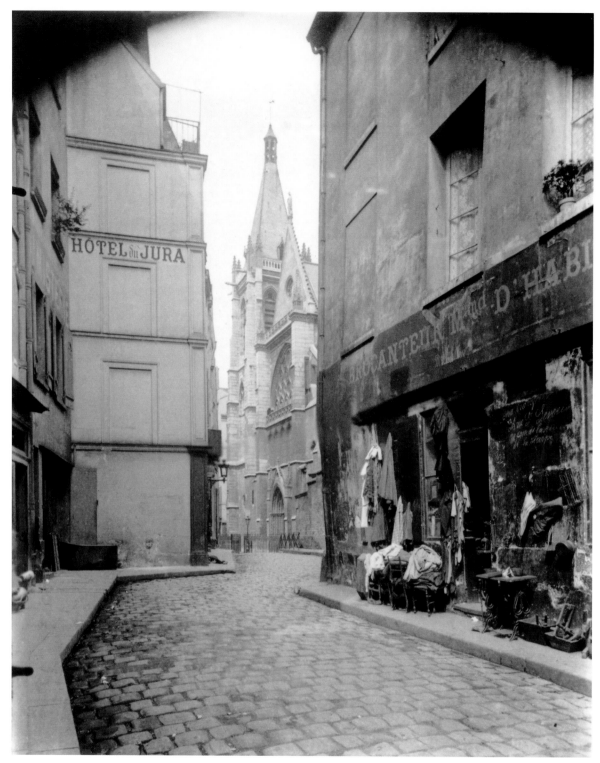

Rue des Prêtres-Saint-Séverin, 1903

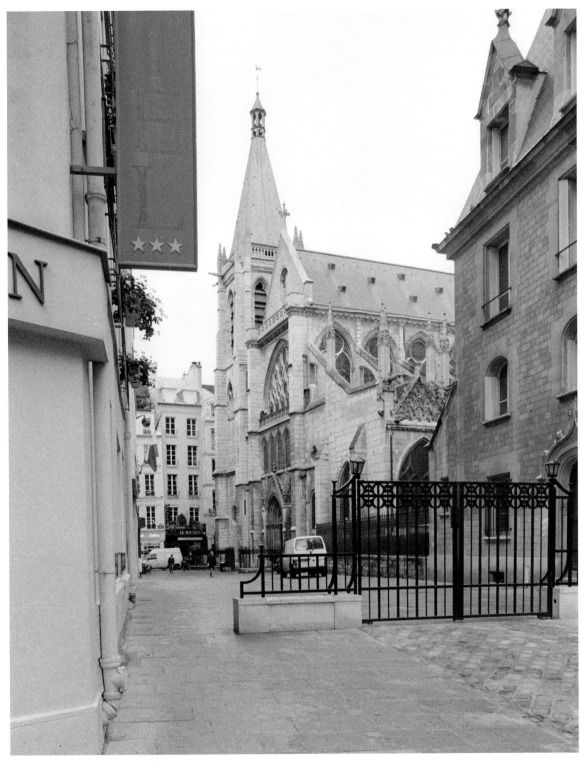

Rue des Prêtres-Saint-Séverin, 1998

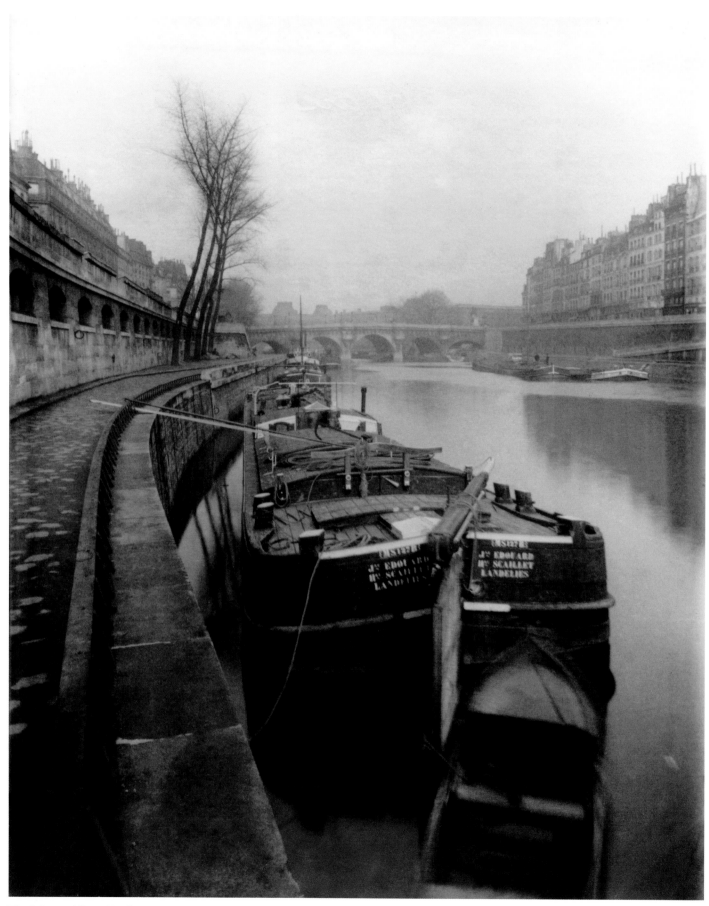

The Seine and Pont-Neuf, 1902–03

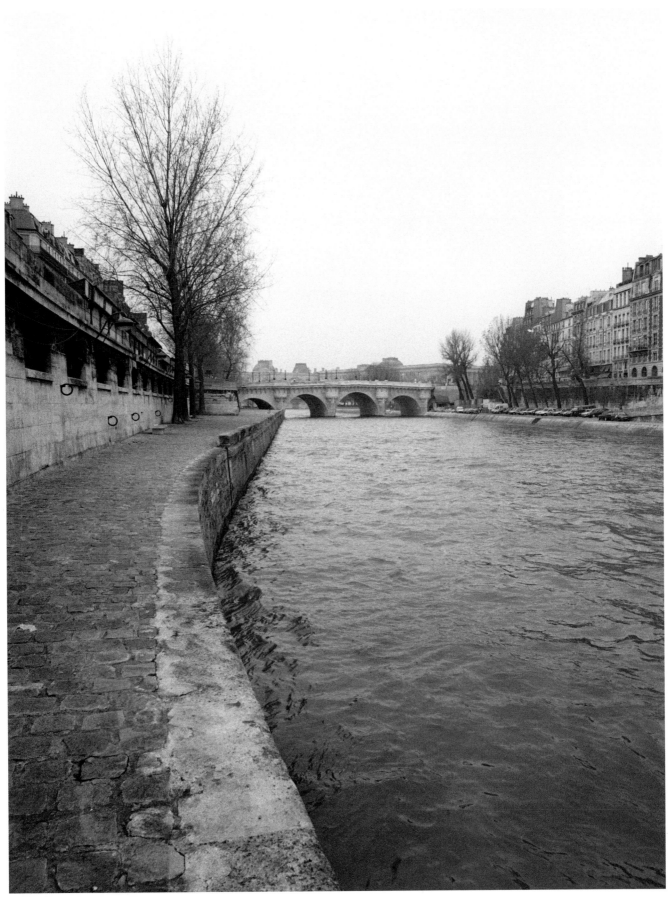

The Seine and Pont-Neuf, 1998

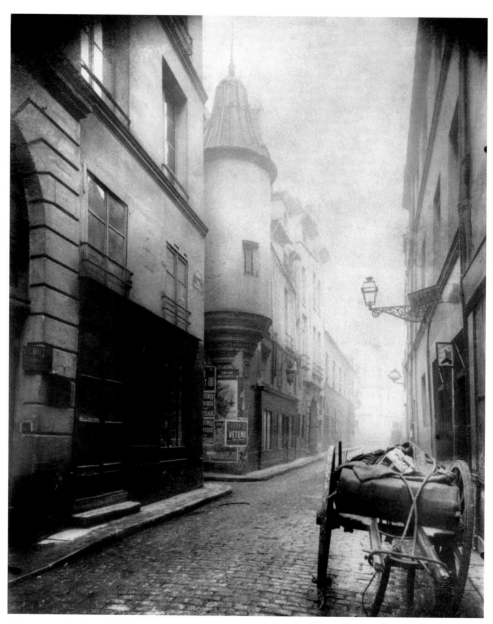

5 Rue Hautefeuille, Hôtel de Fécamp, 1898

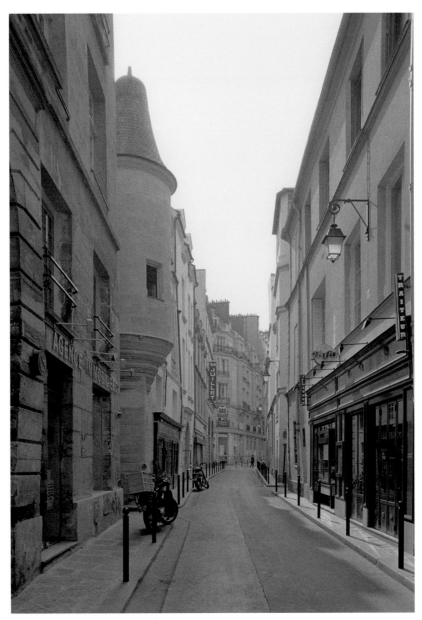

5 Rue Hautefeuille, Hôtel de Fécamp, 1997

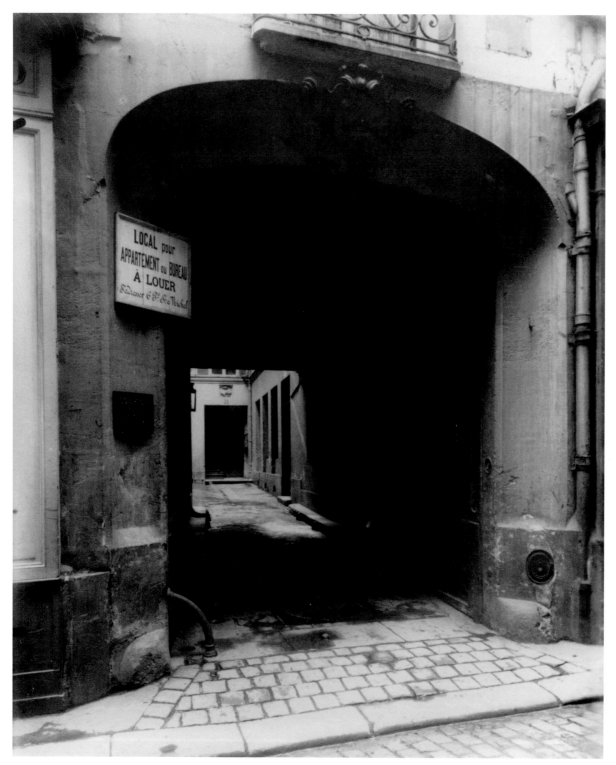

Hôtel de la Salamandre, 20 rue de l'Hirondelle, 1900

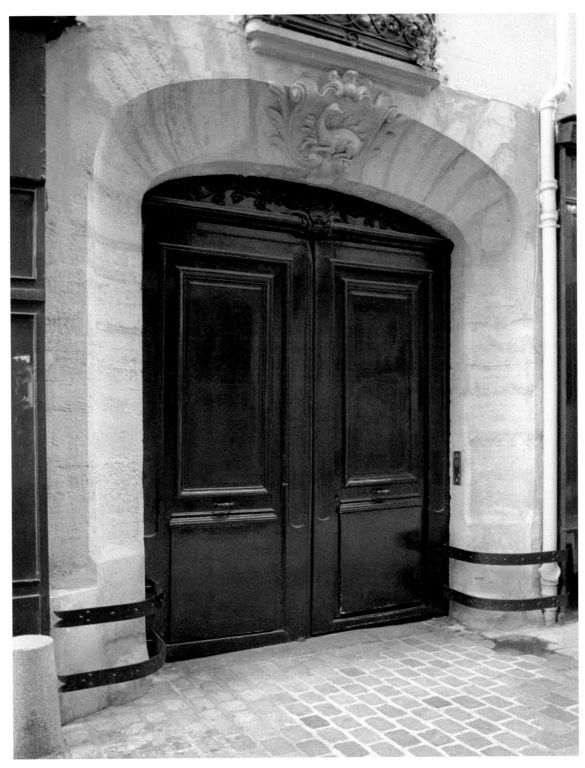

Hôtel de la Salamandre, 20 rue de l'Hirondelle, 1998

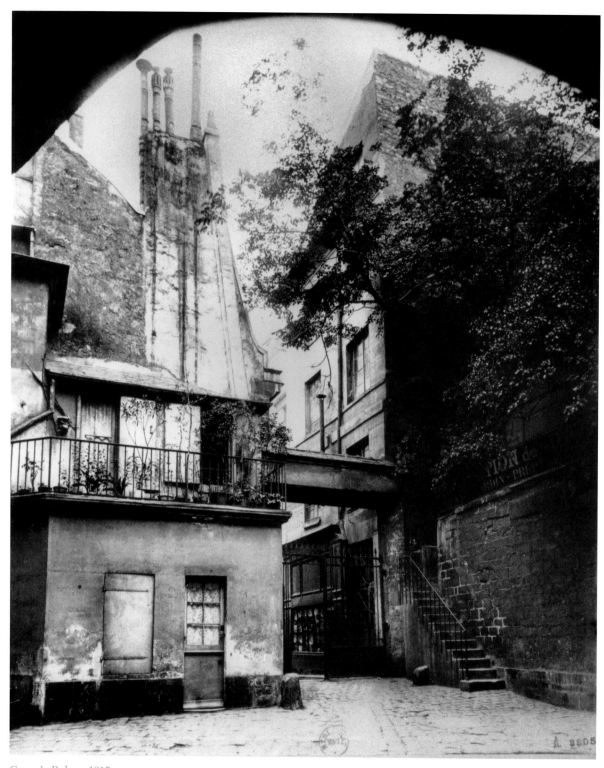

Cour de Rohan, 1915

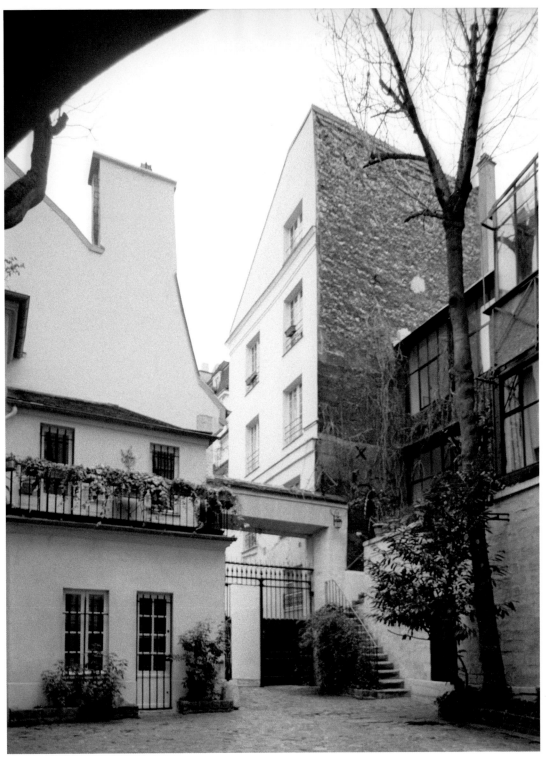

Cour de Rohan, 1998

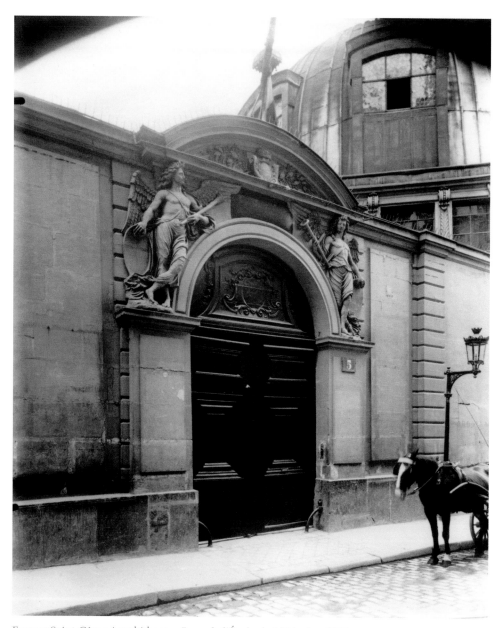

Former Saint-Côme Amphitheater, 5 rue de l'École-de-Médecine, 1898

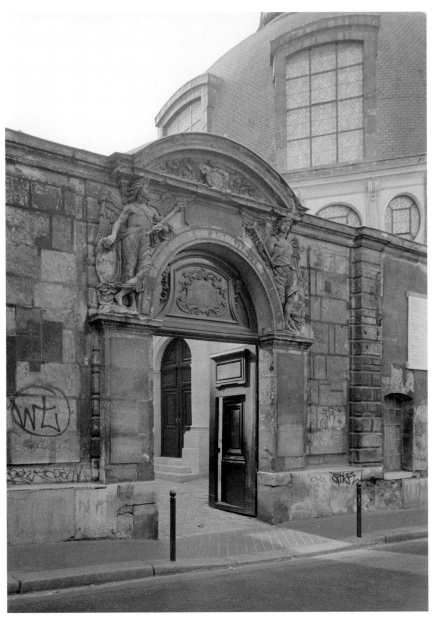

Former Saint-Côme Amphitheater, 5 rue de l'École-de-Médecine, 1997

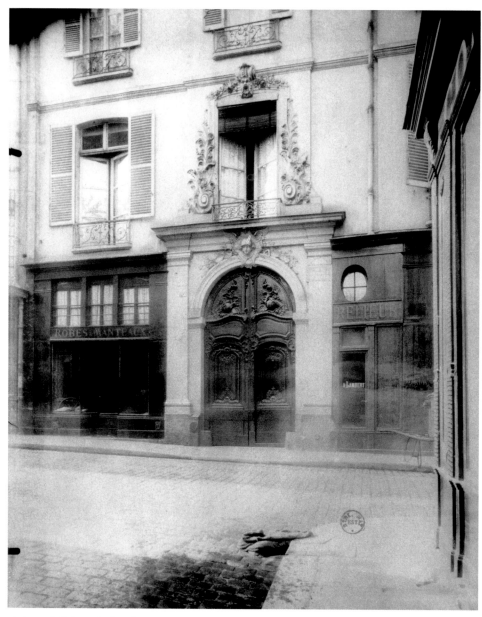

Maison de Prince de Condé, 4 rue Monsieur-le-Prince, 1899–1900

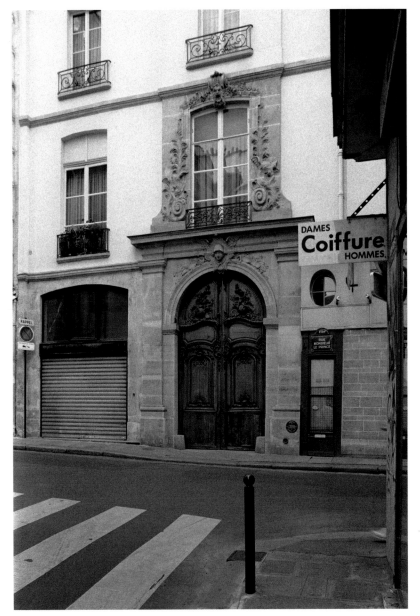

Maison de Prince de Condé, 4 rue Monsieur-le-Prince, 1998

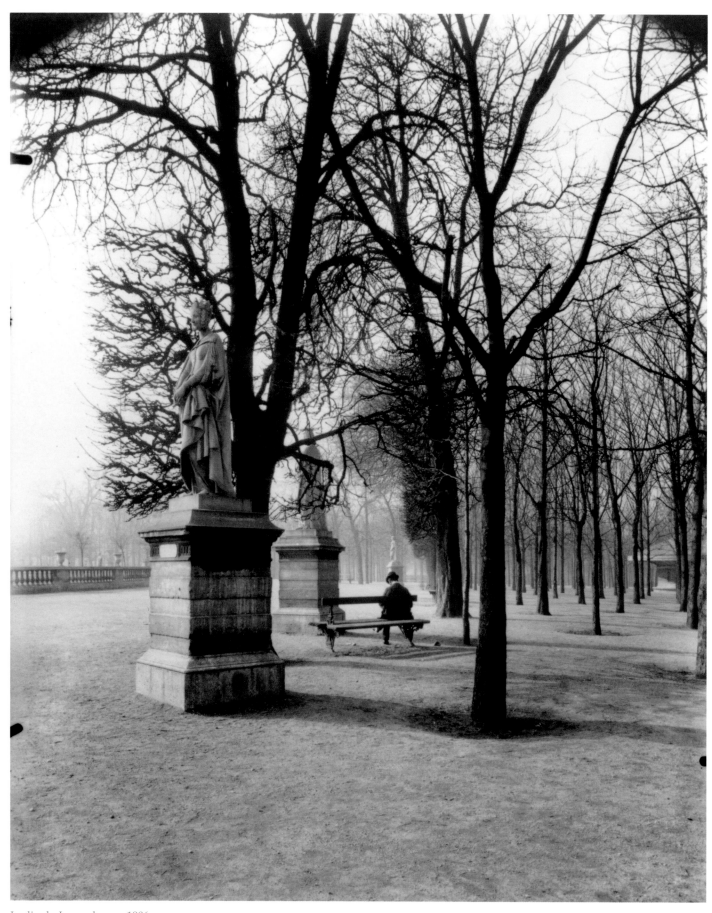

Jardin du Luxembourg, 1906

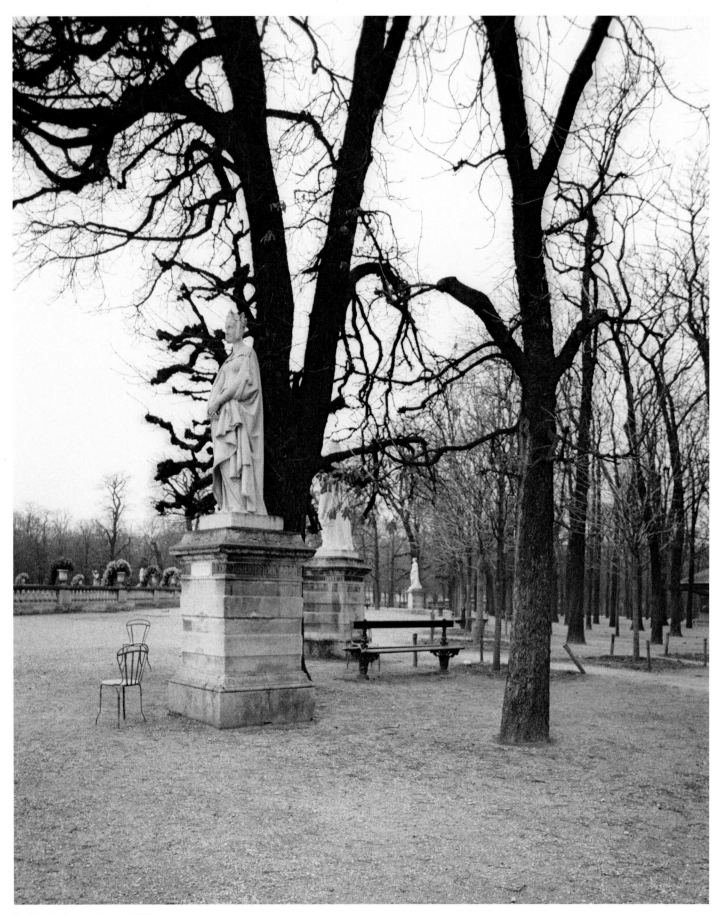

Jardin du Luxembourg, 1998

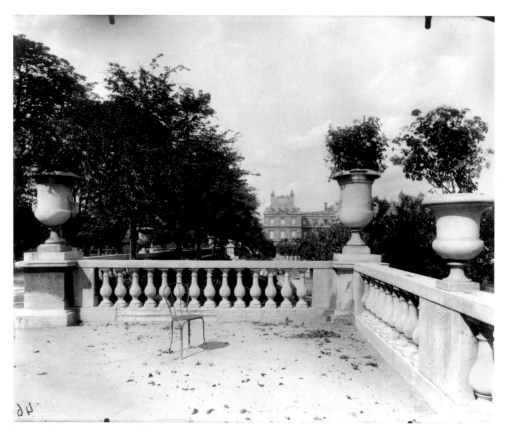

Jardin du Luxembourg, 1902–03

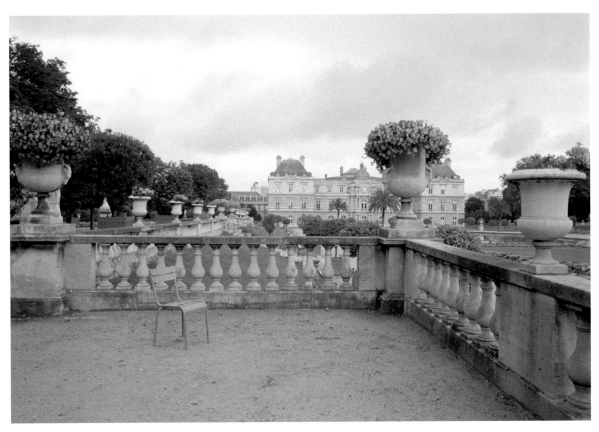

Jardin du Luxembourg, 1998

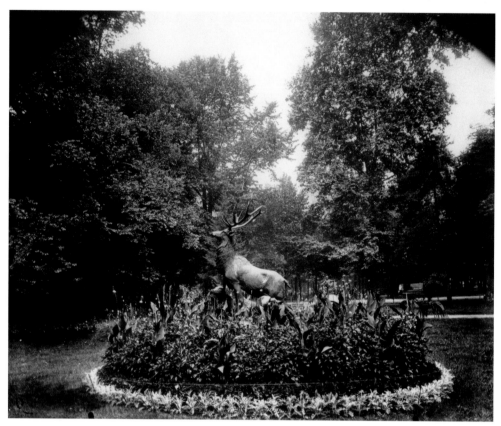

Jardin du Luxembourg, 1906

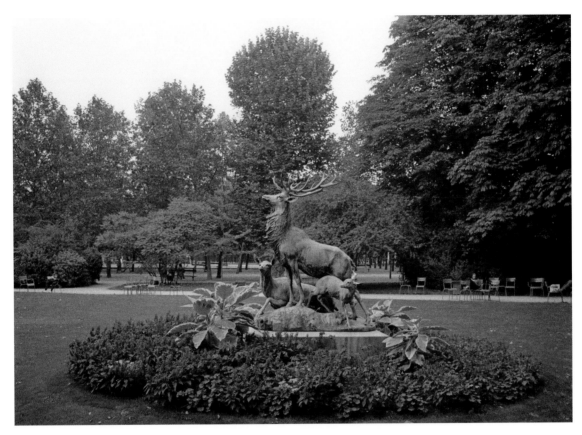

Jardin du Luxembourg, 1997

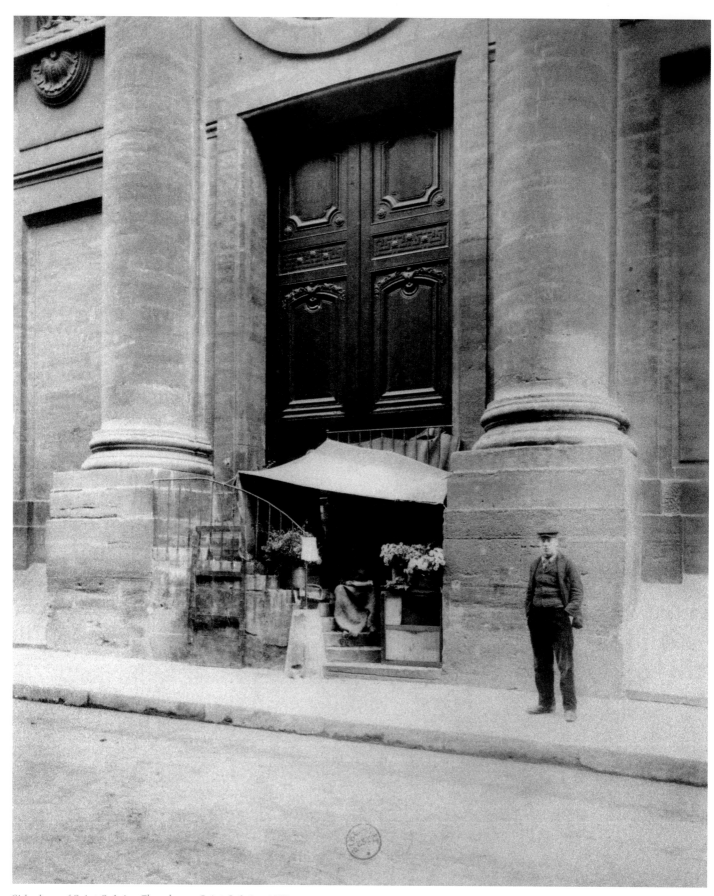

Side door of Saint-Sulpice Church, rue Saint-Sulpice, 1907

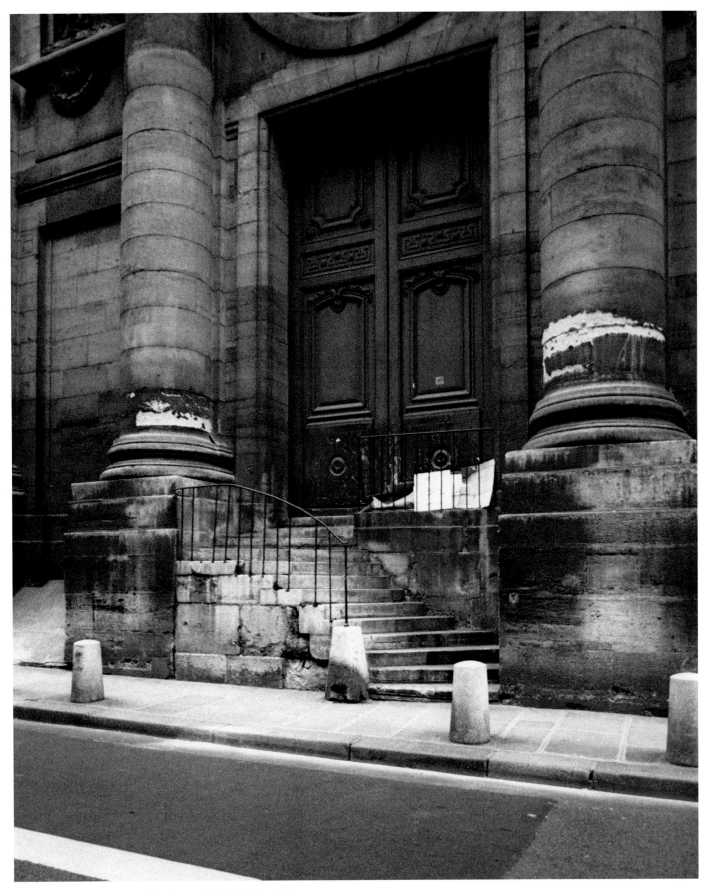

Side door of Saint-Sulpice Church, rue Saint-Sulpice, 1998

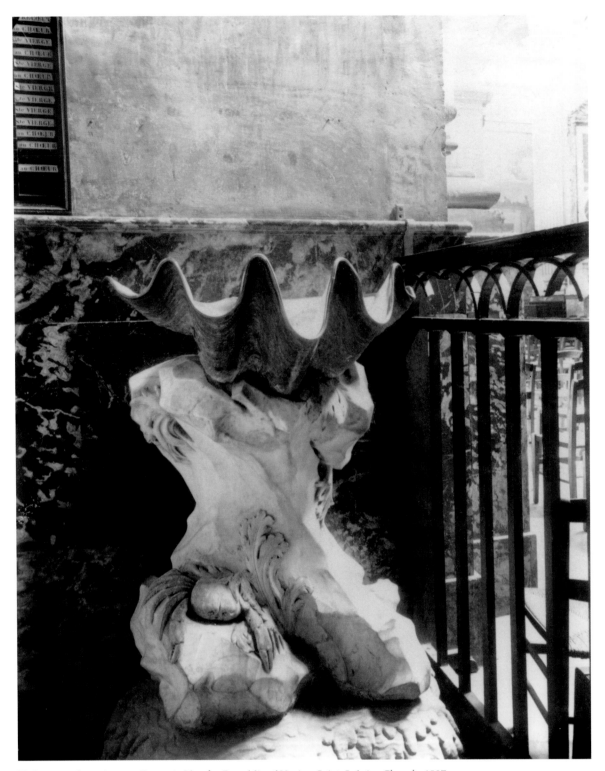

Holy water font given to François I by the Republic of Venice, Saint-Sulpice Church, 1907

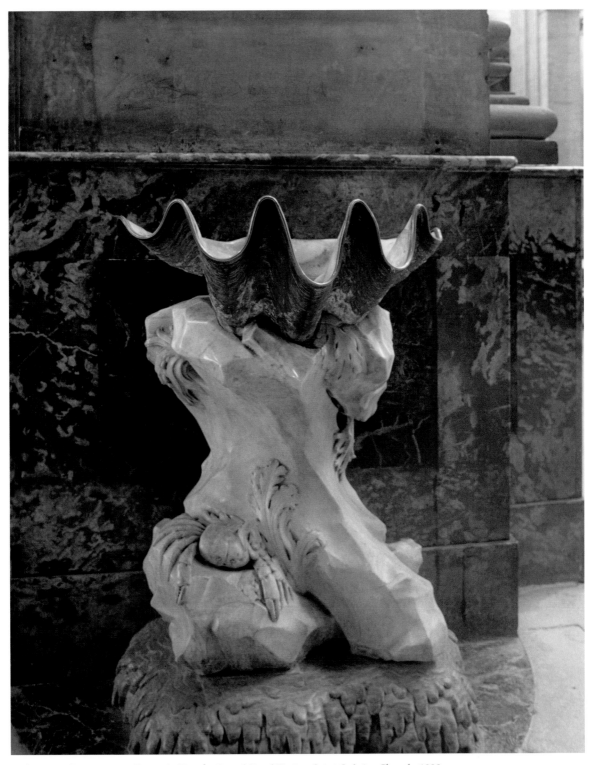

Holy water font given to François I by the Republic of Venice, Saint-Sulpice Church, 1998

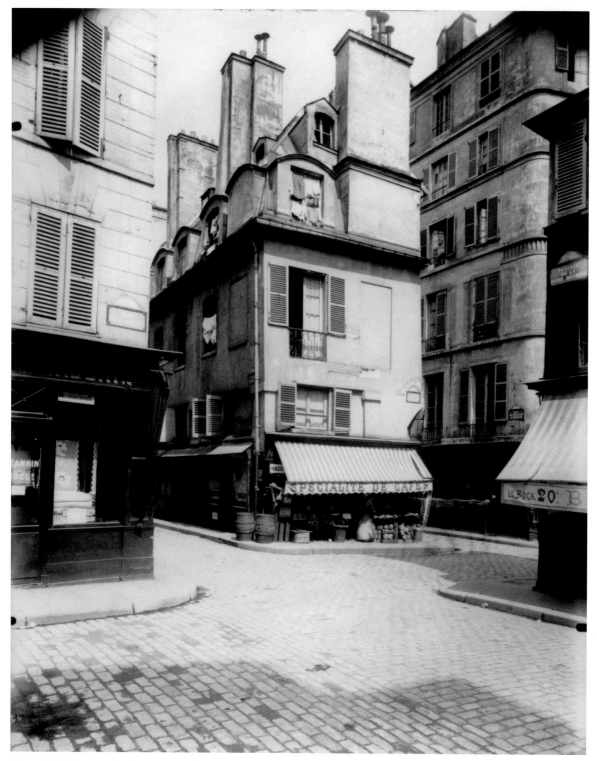

2 rue de l'Abbaye, at the intersection of rue Cardinal, 1907–08

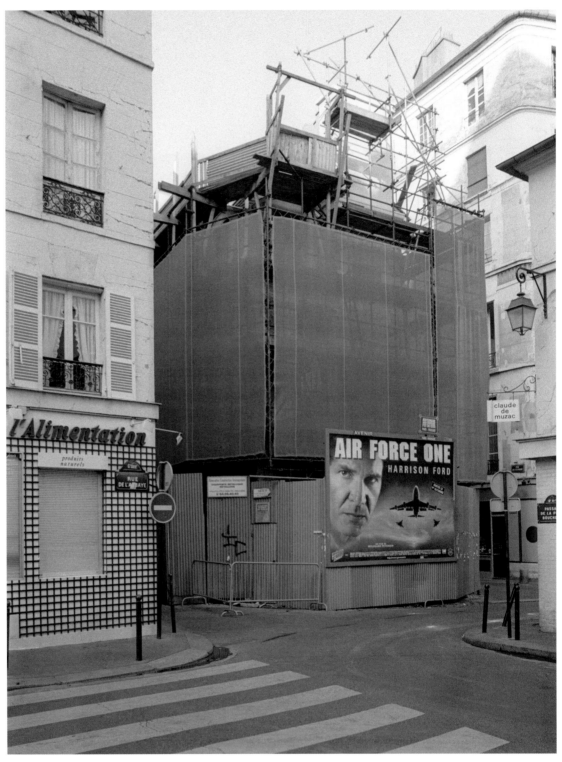

2 rue de l'Abbaye, at the intersection of rue Cardinal, 1997

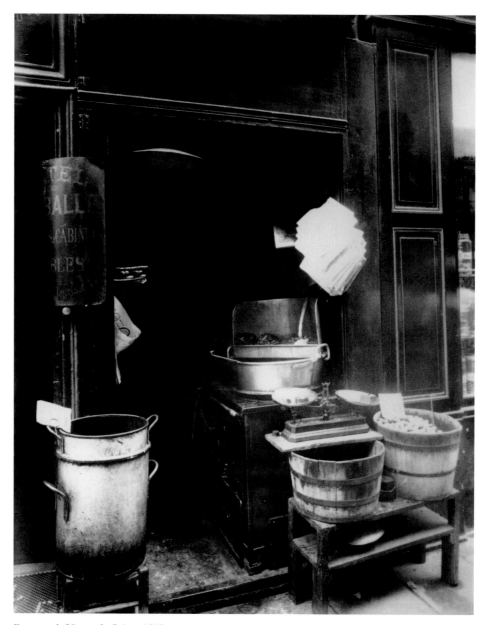

Fry stand, 38 rue de Seine, 1910

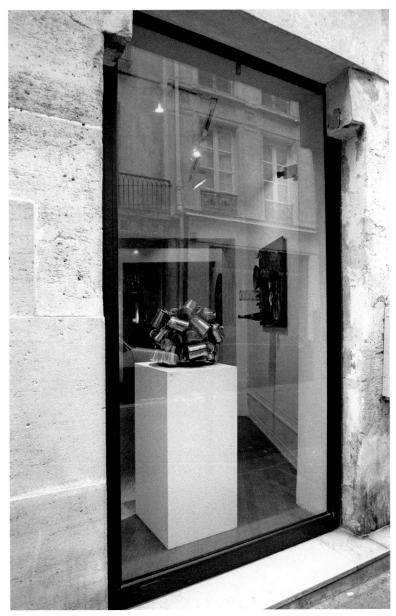

38 rue de Seine, 1998

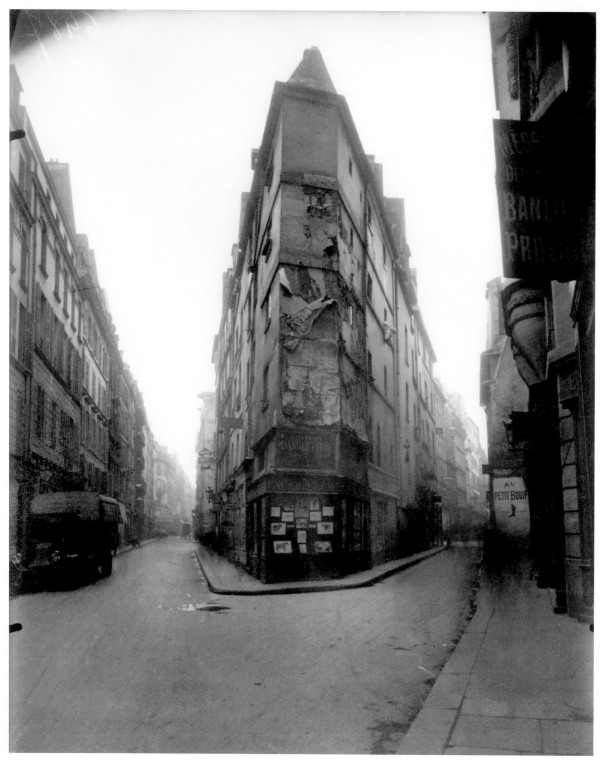

Intersection of rue de Seine and rue de l'Échaudé, circa 1924

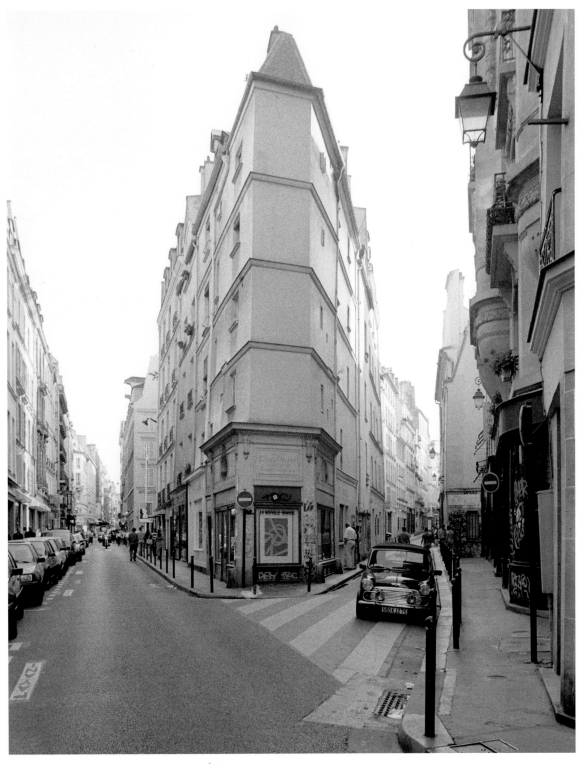

Intersection of rue de Seine and rue de l'Échaudé, 1997

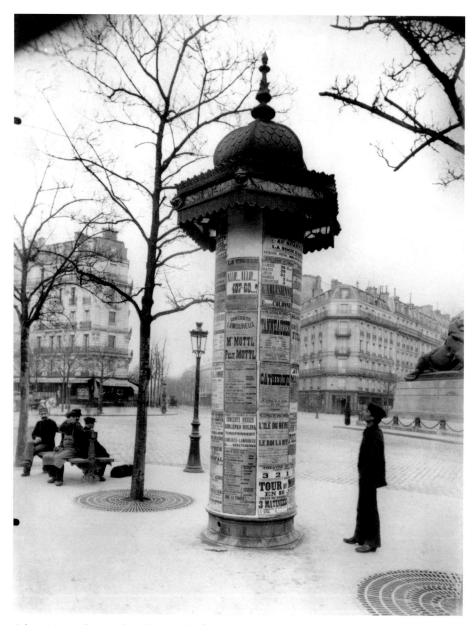

Advertising column, place Denfort-Rochereau, 1900

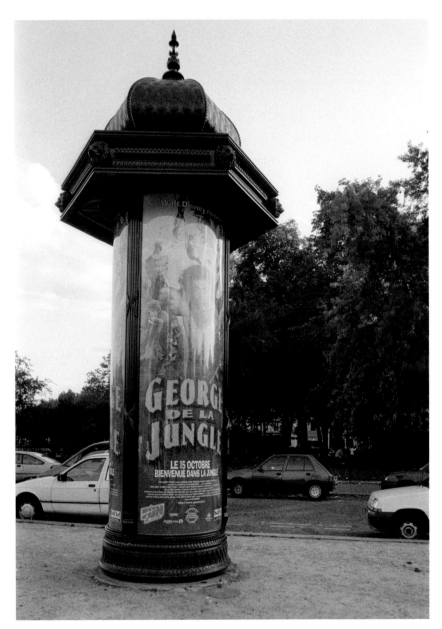

Advertising column, place Denfort-Rochereau, 1997

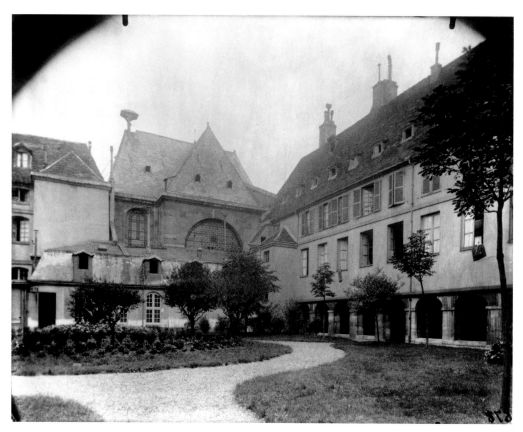

Cour de l'hospice de la Maternité, 1899

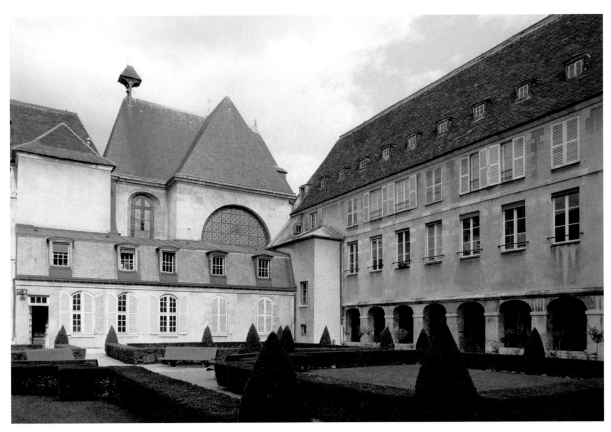

Cour de l'hospice de la Maternité, 1997

Arrondissements 18, 19 & 20

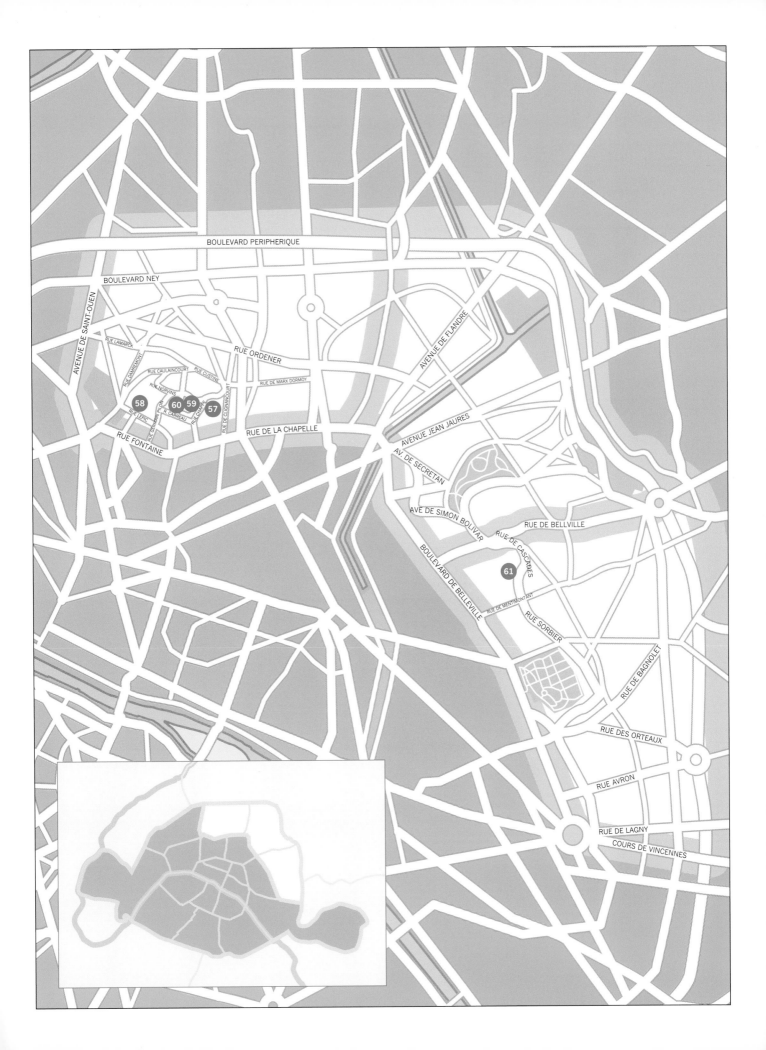

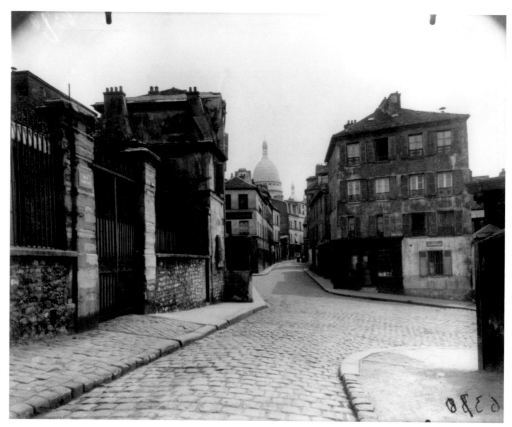

Sacré-Coeur, seen from rue Norvins, 1922

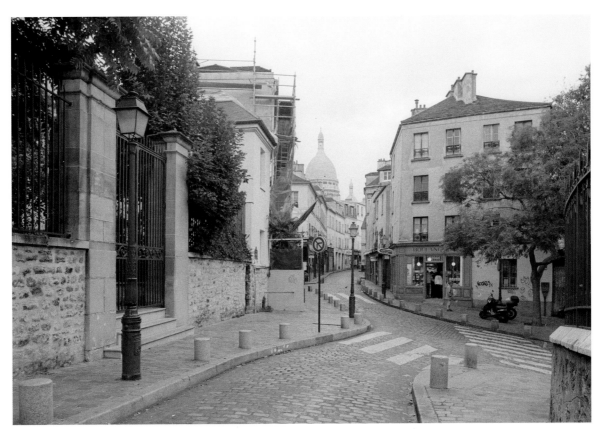

Sacré-Coeur, seen from rue Norvins, 1997

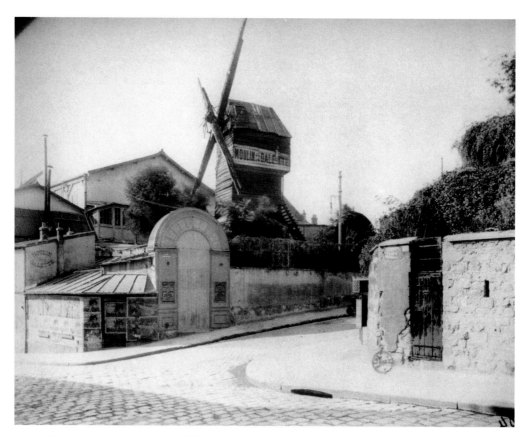

Le Moulin de la Galette, rue Lepic, 1899

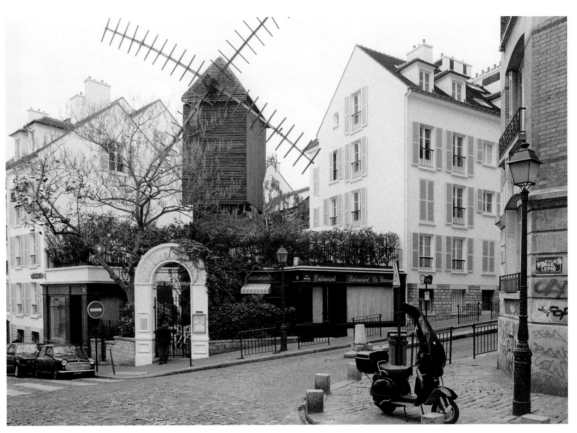

Le Moulin de la Galette, rue Lepic, 1997

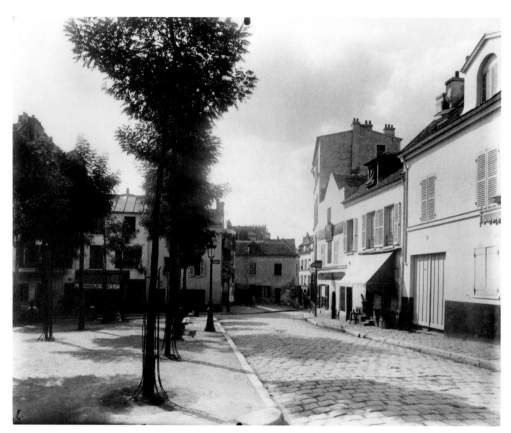

Place du Tertre, 1899

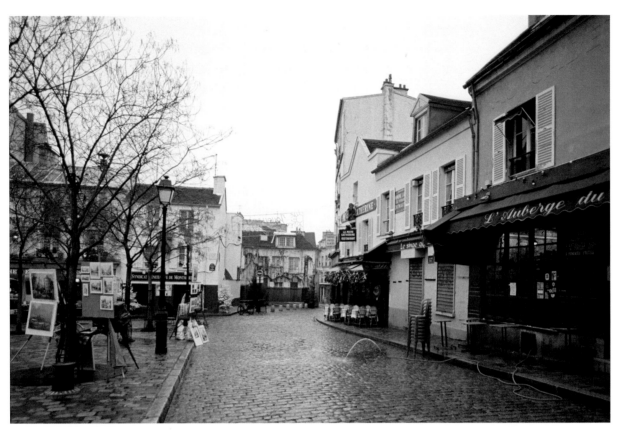

Place du Tertre, 1998

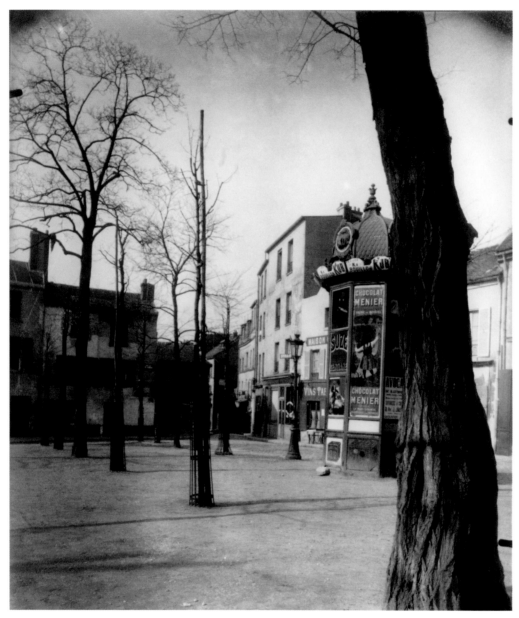

Place du Tertre, 1899

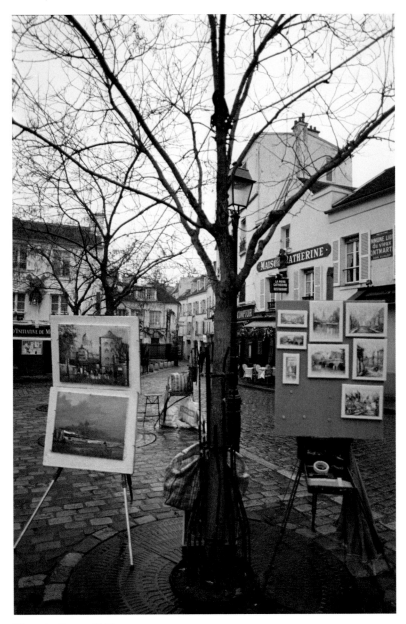

Place du Tertre, 1998

47 rue des Cascades, 1901

47 rue des Cascades, 1997

Saint-Cloud, Versailles, Sceaux

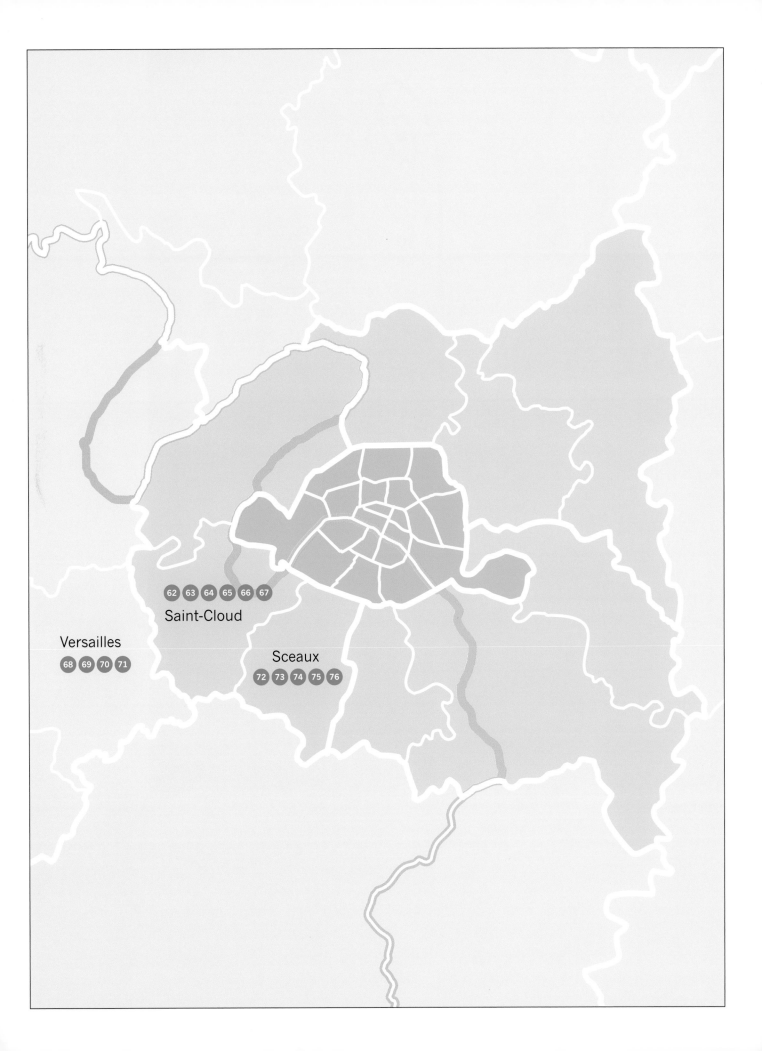

Saint-Cloud

Versailles

Sceaux

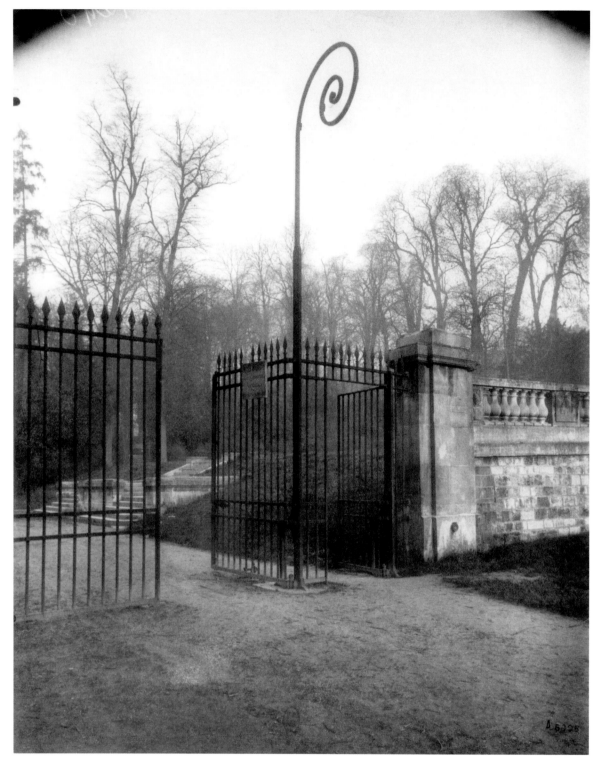

Saint-Cloud, 1924

148

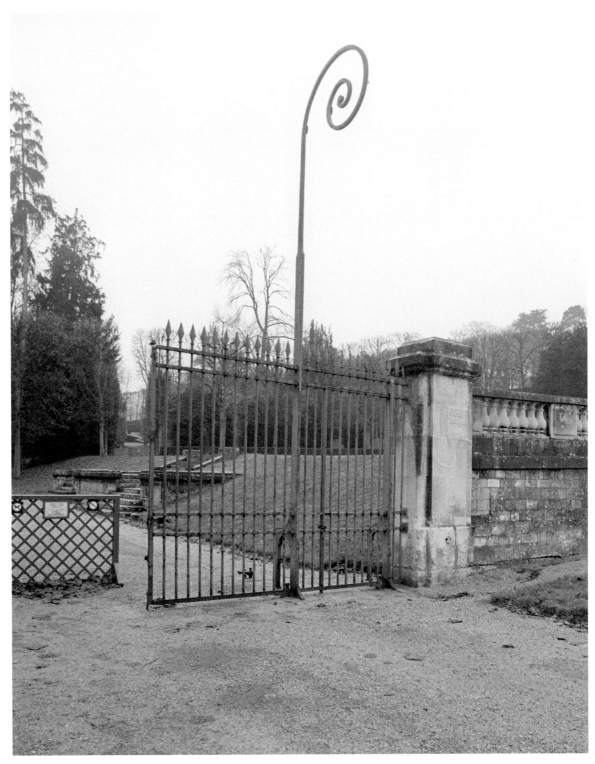

Saint-Cloud, 1998

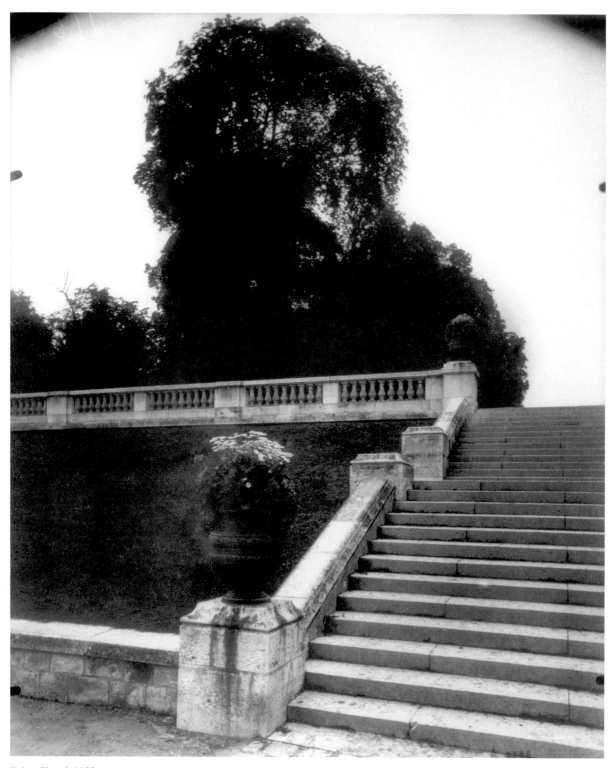

Saint-Cloud, 1922

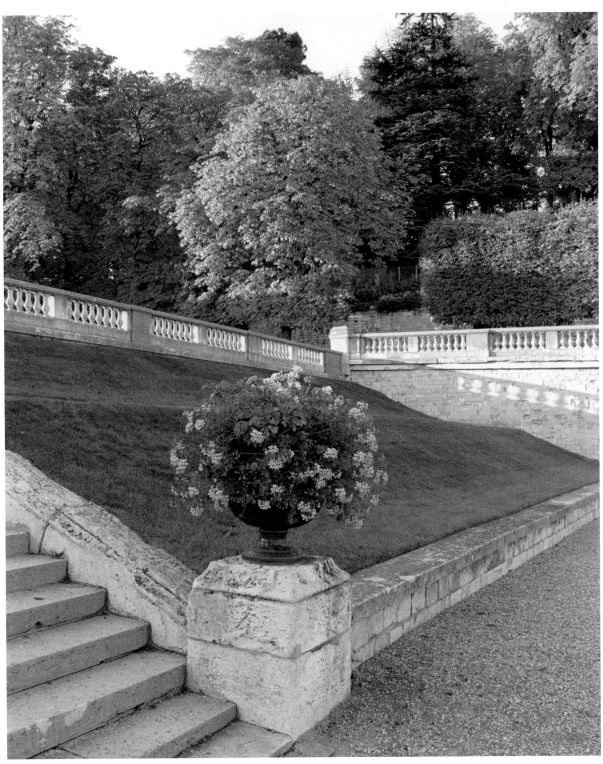

Saint-Cloud, 1989

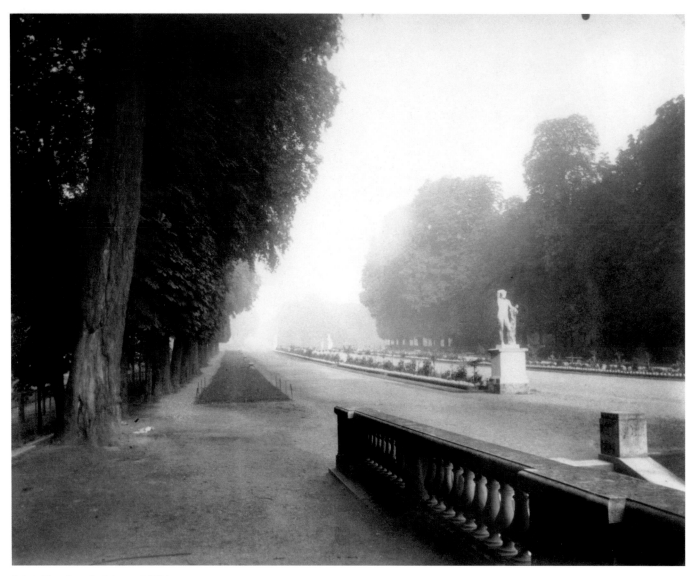

Saint-Cloud, end of August 1924

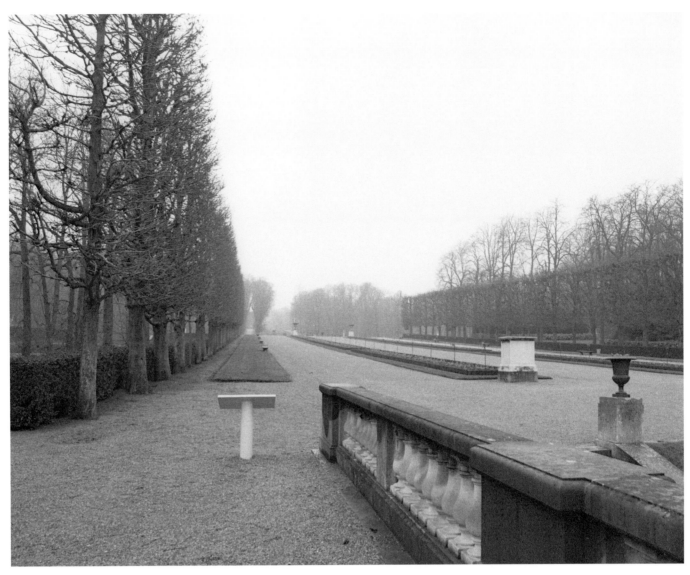

Saint-Cloud, December 1998

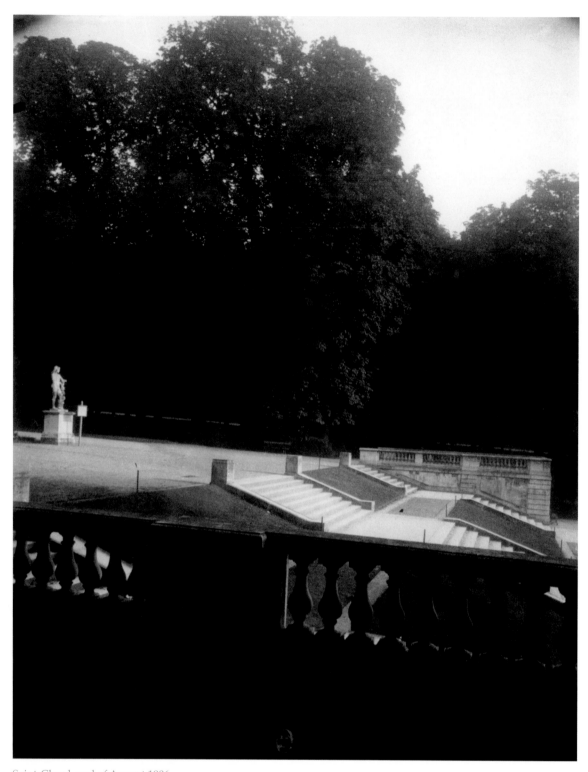

Saint-Cloud, end of August 1906

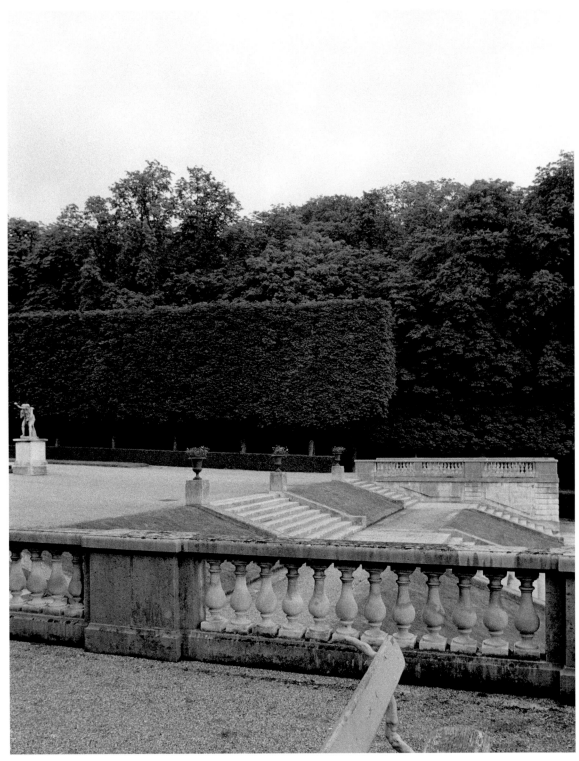

Saint-Cloud, July 1998

Saint-Cloud, 1923

Saint-Cloud, 1998

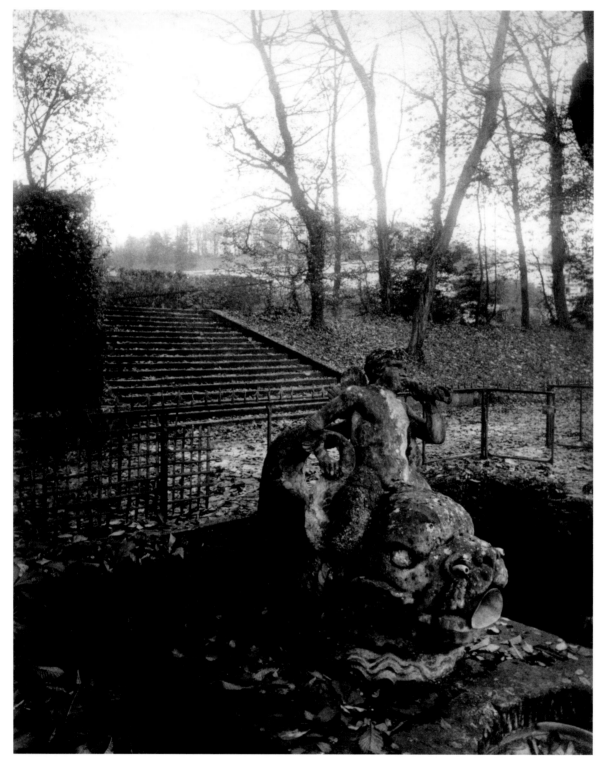

Saint-Cloud, 1906

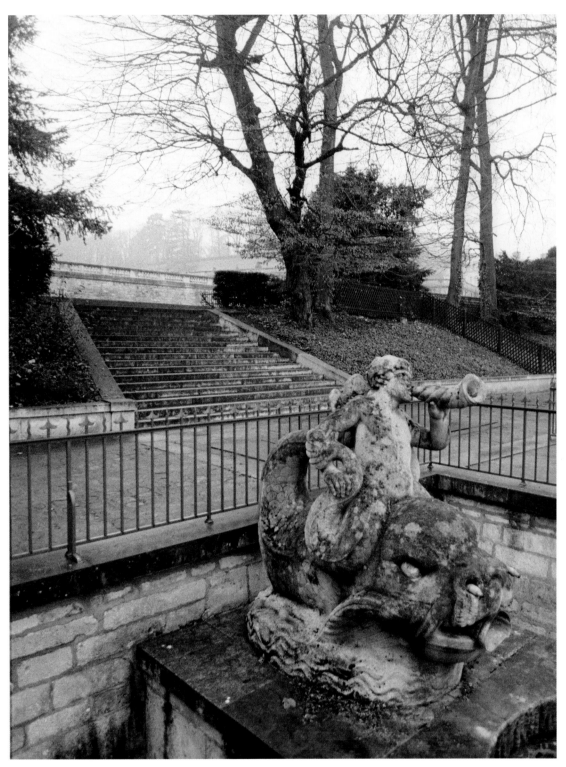

Saint-Cloud, 1998

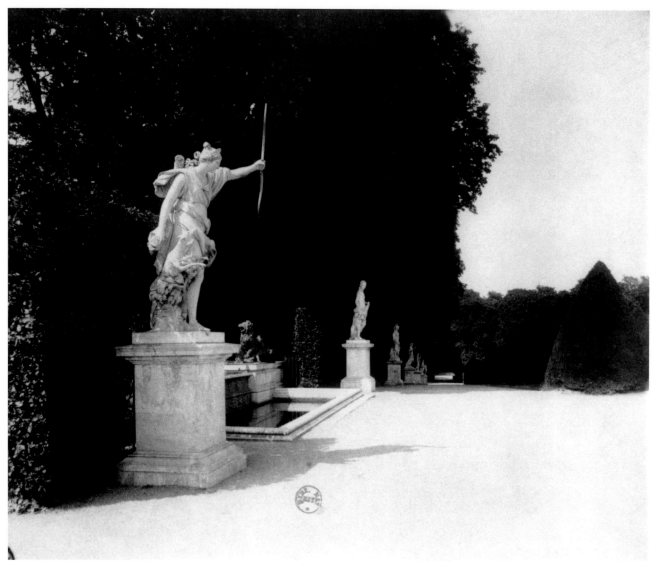

Versailles, 1901

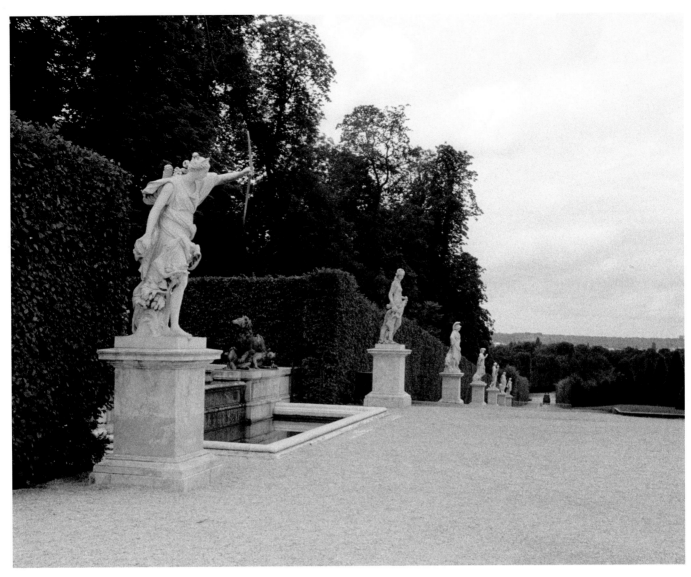

Versailles, 1998

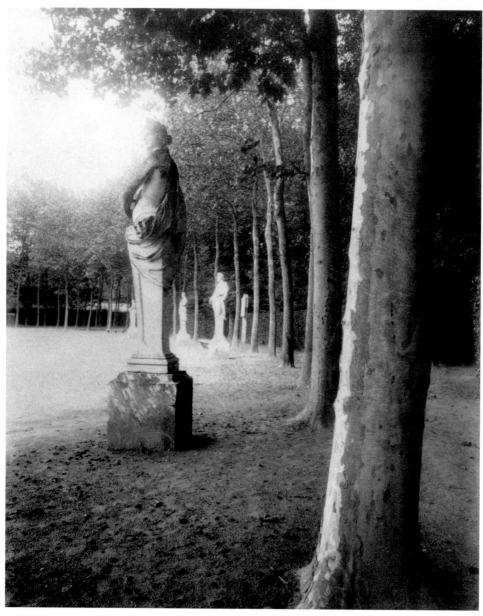

Park of Versailles, 1902

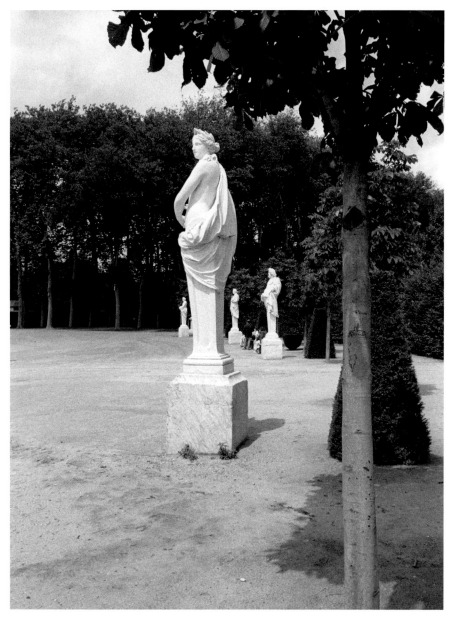

Park of Versailles, 1998

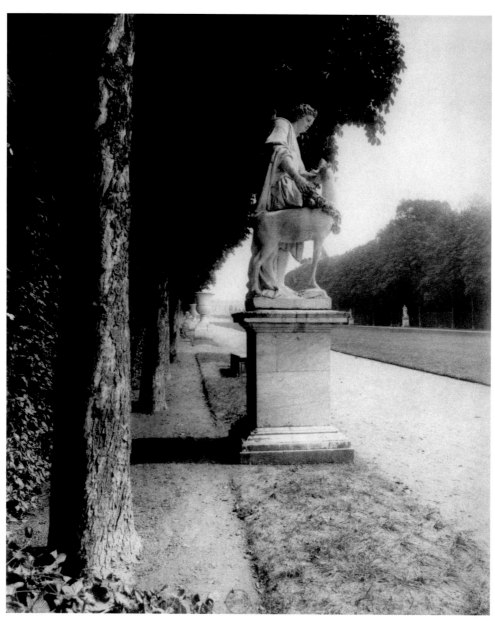

Versailles, statue of Cyparisse by Flamen, 1902

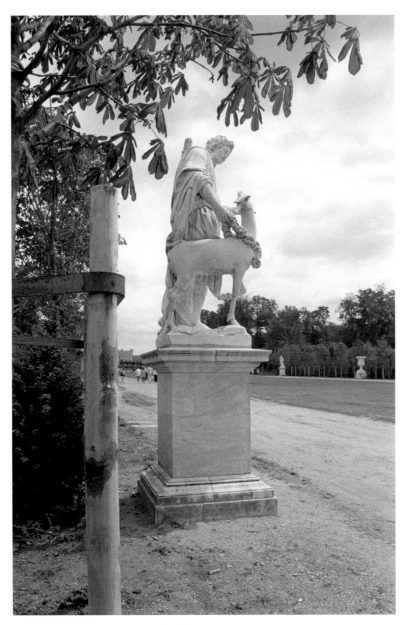

Versailles, statue of Cyparisse by Flamen, 1998

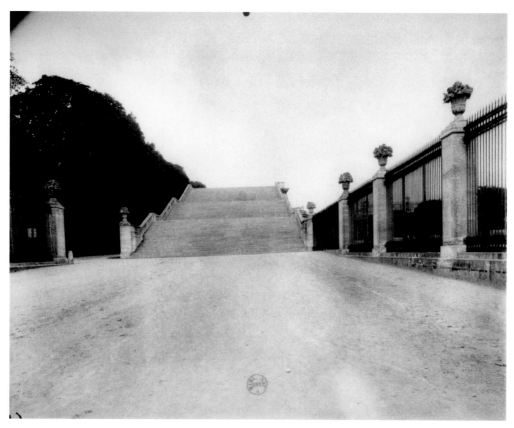

Versailles, escalier de l'Orangerie, 103 steps, 20 meters high, July 1901

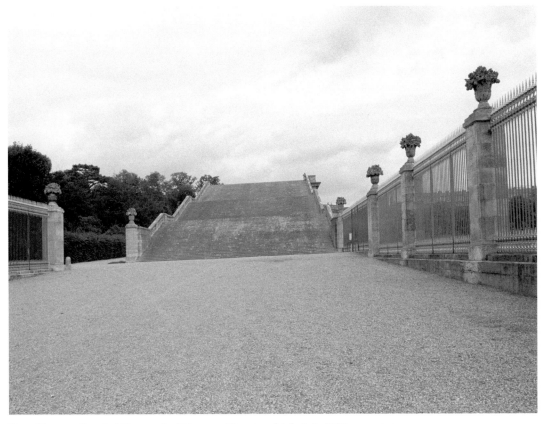

Versailles, escalier de l'Orangerie, 103 steps, 20 meters high, July 1998

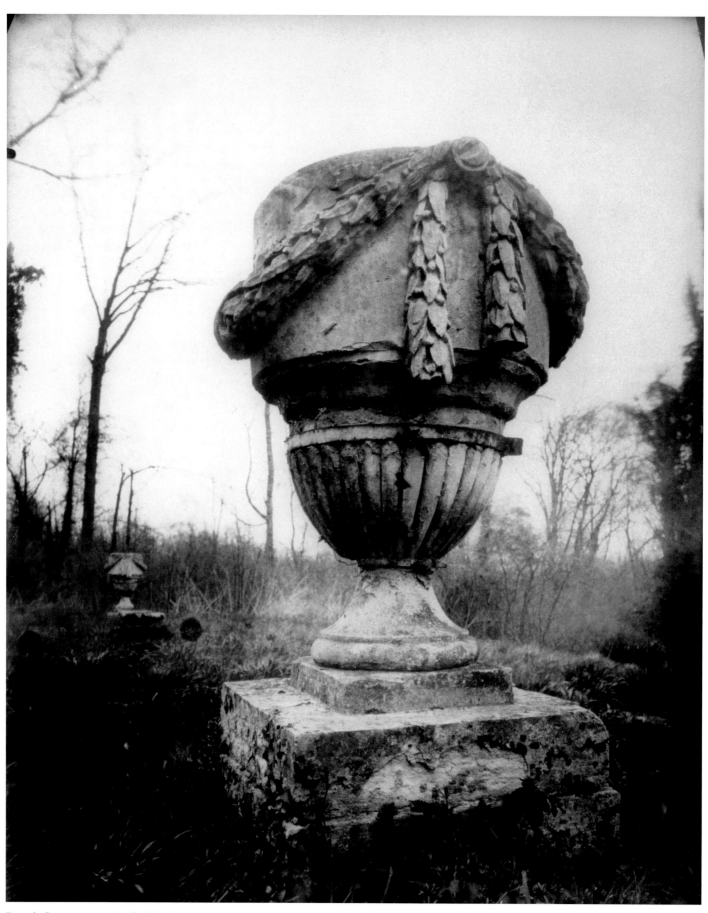

Parc de Sceaux, vase, April 1925, 7 a.m.

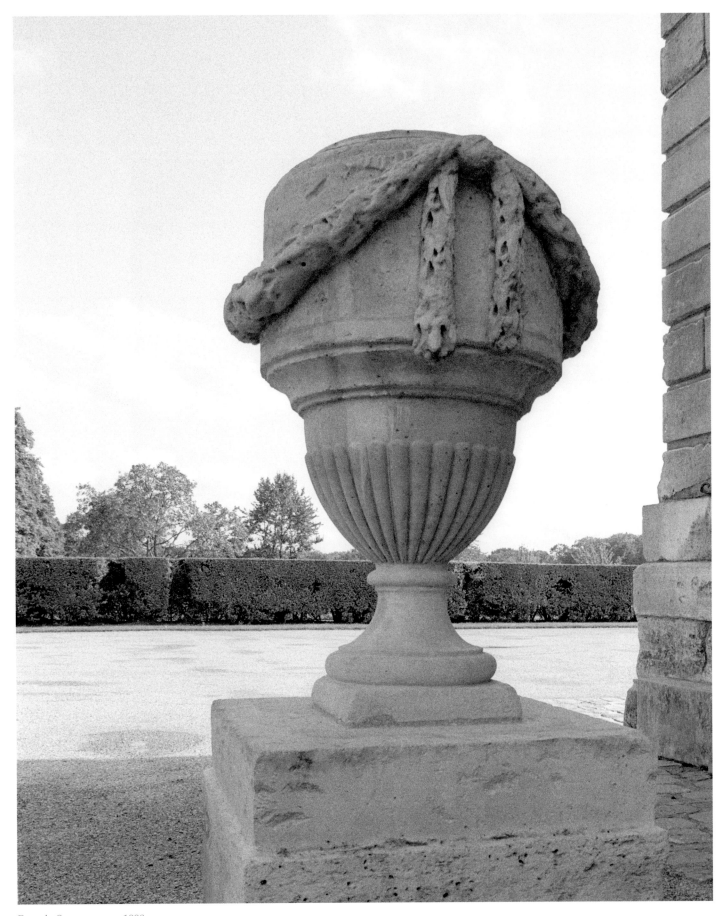

Parc de Sceaux, vase, 1998

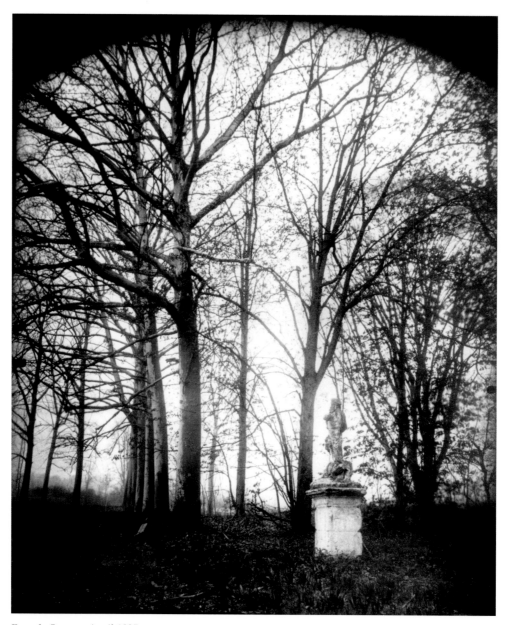

Parc de Sceaux, April 1925

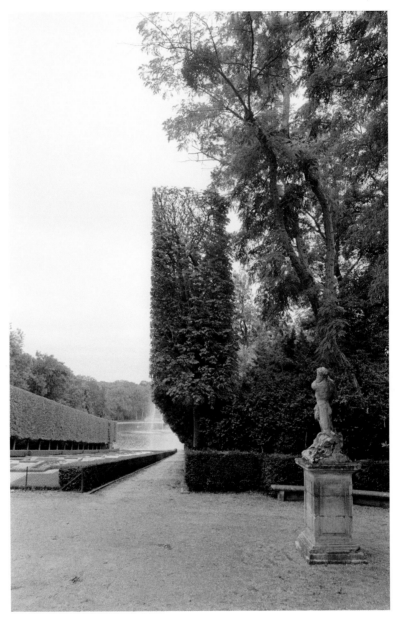

Parc de Sceaux, December 1998

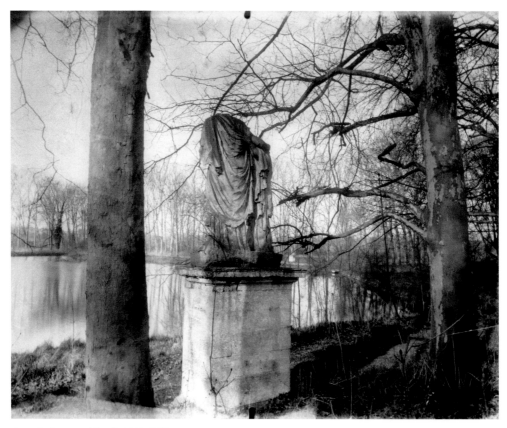

Parc de Sceaux, March 1925, 7.30 a.m.

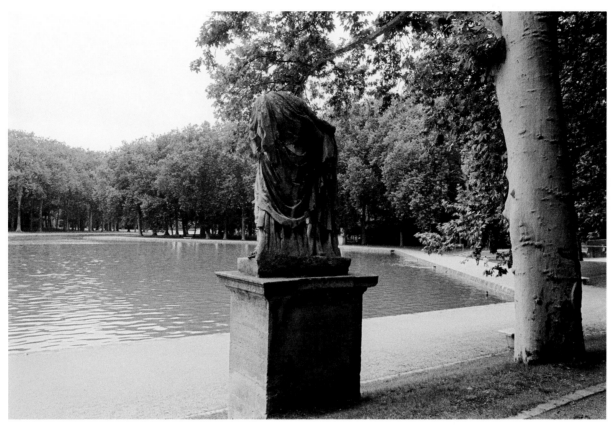

Parc de Sceaux, 1998

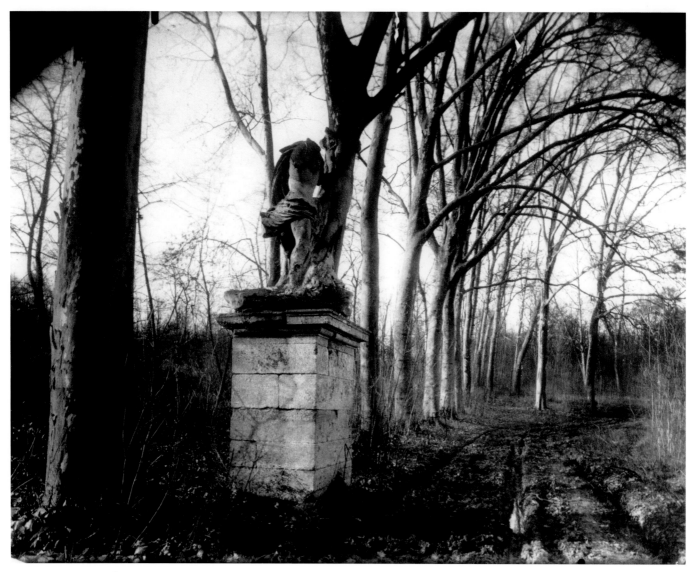

Parc de Sceaux, March 1925, 8 a.m.

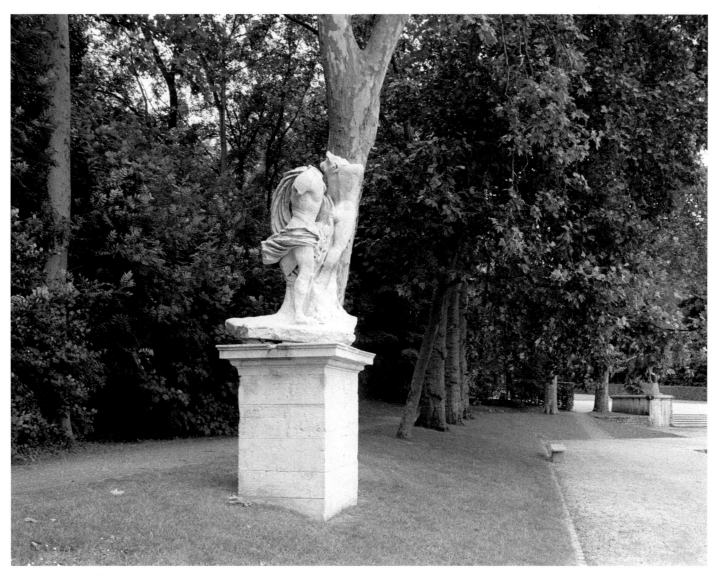

Parc de Sceaux, 1998

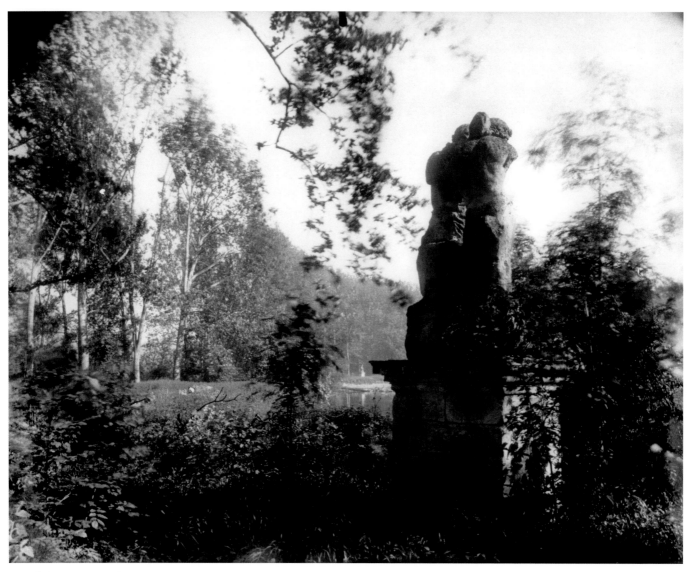

Parc de Sceaux, June 1925, 7 a.m.

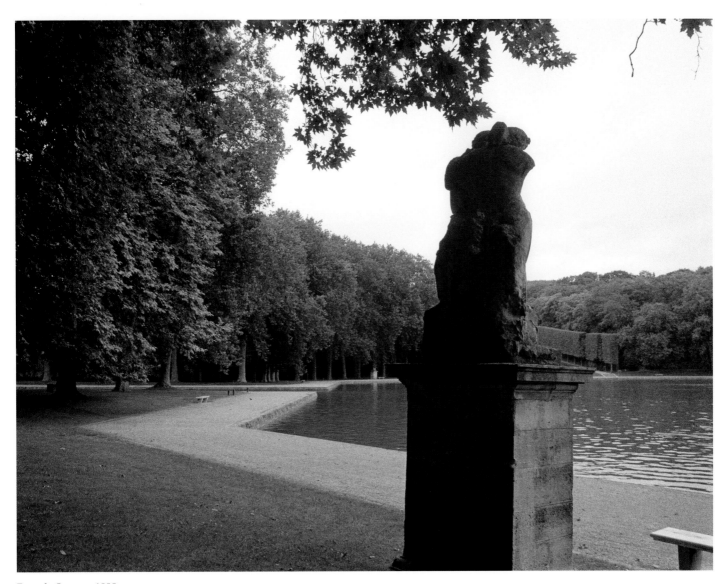

Parc de Sceaux, 1998

Paris Regained

Rosamond Bernier

Looking at these hauntingly evocative Atget images and the equally evocative latter-day photographs by Christopher Rauschenberg that are like the sympathetic vibrations set off by certain musical sounds, I think of my days in Paris all over again.

I had lived in Paris during the 1950s and 1960s, always in the seventh arrondissement, and these photographs make me want to visit my old haunts again, not with a camera, but with a new lens, a pair of eyes: How much is it *plus ça change*? How much is it a new look, not necessarily for the better?

I lived for many years in a handsome eighteenth-century house on the rue du Bac that was owned by a substantial bourgeois family of stinginess worthy of a Balzac novel. The S. family (principally old Madame S. and her son, Jean) occupied the grand first floors; an impressive stone staircase led to their quarters. Our more modest top floors were reached by narrow, dimly lit stairs, and a small cage of an elevator. Through its open-work metal door you could peer in at the other apartments as you creaked your way upward. One time I caught sight of old Madame S. on her knees, scrubbing the Versailles parquet with a toothbrush.

Another relation, Professor Daniel S., who lived on the floor above Madame S. and her son, had lost a hand in some undisclosed accident. He had not invested in a normal prosthesis but had a metal hook, the kind worn by the pirate Captain Hook, which used to scare me as a child in the story of Peter Pan. One of the more disconcerting sights was his hook emerging from the elevator gate, pushing it to one side.

When something went wrong with the heating in our apartment, which was minimal at best, Monsieur Jean would show up, tall and distinguished of aspect. He was too mean to call in a professional and used to appear clad in what I thought of as his Do-It-Yourself suit, frayed and somewhat short at the wrist. Down on his knees he would go and tap the radiators hopefully with some archaic device.

In those days, the concierge occupied a dark cubbyhole at the left of the big entrance door and would pull the cord to open the door that admitted you. No more—the reign of the concierge is over. No longer can you wander into a courtyard to admire the garden at the back— you have to know the "code" and tap in the proper numbers on the panel at the building's street entrance. If you don't know the code and are expected for dinner, you will never make it.

In Paris recently, I went by my old address on the rue du Bac. By luck, someone was coming out of the house, so I could slip into the entrance hall. There were the names of the

present occupants, all presumably younger members of the S. family—*plus ça change*. There was one exception; the elegant little pavilion at the back of the courtyard used to be occupied by the great bookseller/collector Pierre Bérès. He died not long ago, and I recently read an account of the auction sale of his stupendous holdings—an original edition of Diderot's encyclopedia, rare illuminated manuscripts, magnificent bindings. It took several days to complete the sale, which made record prices.

Before I moved to the rue du Bac, I lived at the Hotel Pont Royal, nearby on the rue Montalambert. It was nondescript but convenient. I had a small room with a turkey-red carpet and an old-fashioned telephone on a cradle, which functioned only intermittently. Once, maddened by not getting any response from the hotel telephone operator, I stormed downstairs and found her outside of her little cage, being measured for a dress by a friend.

The Pont Royal was the temporary home for a number of people whom I knew. Fred, the concierge, was an invaluable honorary assistant. "Monsieur Miró is arriving tomorrow to work on his engravings with Monsieur Moulot," he might tell me, or "Monsieur Matisse telephoned for you and left a message, he wants to know where Monsieur Skira is."

Downstairs was the bar, a convivial meeting place. The publishing house of Gallimard was just down the street, so the hotel bar attracted a number of house authors and their friends. That is where I first met Albert Camus, Balthus, and the soon to be famous psychoanalyst, Dr. Jacques Lacan. Dr. Lacan lived and practiced at number 7 rue de Lille. Now, number 7 is the locale of Karl Lagerfeld's very chic new bookstore, specializing in his particular interests: photography, poetry, and architecture.

On my recent trip to Paris I went to see the Hotel Pont Royal. "*Quelle horreur!*" as a Nancy Mitford heroine might say. It was all tarted up in an unconvincing attempt at being bohemian, with a display of irrelevant portrait photographs that included Oscar Wilde. And my dear, dusky bar no longer existed at all—instead, it had been shrunk into a slither tucked into a corner of the new shiny black-and-white lobby, with two or three bar stools.

At the other end of the rue du Bac was, and is, the Bon Marché, the oldest department store in Paris, partly designed by Jean Eiffel. It had been the model for Emile Zola's *Au Bonheur des Dames*. In my day, it was cluttered and fusty, the kind of place where Madame de Gaulle might and did do her shopping. It would never have occurred to me to go there. Now, the Bon Marché has a completely new life as one of the most stylish emporiums in town, and its extraordinarily abundant and *recherché* food department was recently eulogized in the *New York Times*.

Other local shopping news is less rosy. Throughout what used to be my neighborhood, the seventh and sixth arrondissements, the deliciously quirky Mom and Pop stores offering their specialties have been replaced. Now, there are deadeningly second-string

branches of well-known labels in a second-rate echo of the Faubourg Saint-Honoré. There are endless shops offering undistinguished "modern decoration."

The legendary Saint-Germain des Prés cafés, the Flore and the Deux Magots, where once Sartre and Simone de Beauvoir kept regular office hours and Alberto Giacometti might drop by for one more very late night drink, have lost their character. Only the greenest of tourists would hang out there to pay $10 for a cup of coffee.

However, the charcuteries, the patisseries, the *fruits et legumes,* and the prepared food shops are as glorious and seductive as ever (and even more expensive). The wonderful cheese shop Barthélémy on the rue de Grenelle, the Tiffany of cheese, still displays its chalky-crusted varieties like precious jewels. And when buying, you are asked with almost reverent concern: "Is it for today or tonight? And at what time?"

The restaurants are, as a whole, as inspired and even more pricey than ever. Where else but in Paris would there be a restaurant called "Le Soufflé" that offers fifteen kinds of soufflés along with an ample spoonful of the appropriate sauce to be ladled into its lofty crater?

And where else but in Paris would a photographer be able to stand in the footprints of his predecessor of one hundred years before and still see so many of the same buildings, the same facade decorations, the same street furniture?

In Atget's Shoes

Christopher Rauschenberg

As I traveled through Paris rephotographing Atget's images, I kept
seeing places that he had not photographed but that seemed to me to
be also rich with the feeling of his work. I photographed hundreds
of those places where I felt Atget's spirit. I don't claim that Atget would
have photographed those places. I was simply walking around Paris
"in Atget's shoes," and this is where they took me.

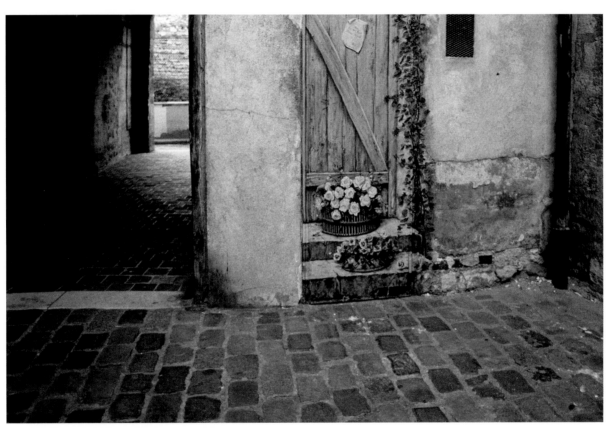

Courtyard, Village St. Paul, 21 rue St. Paul, 1997

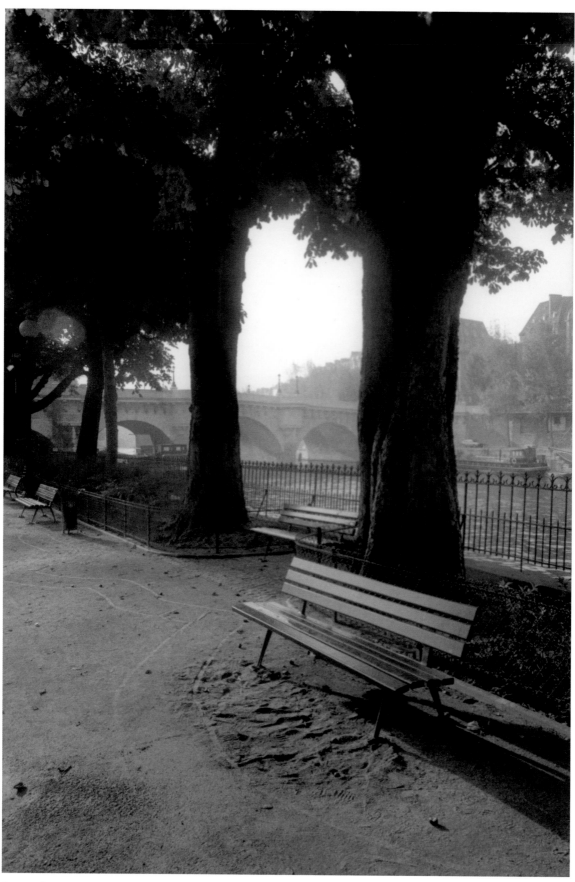

Square de Vert-Galant, 1997

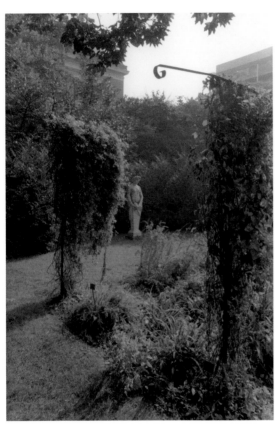

Jardin des Plantes, 1997

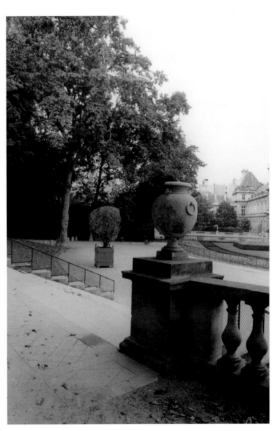

Jardin du Luxembourg garden, 1998

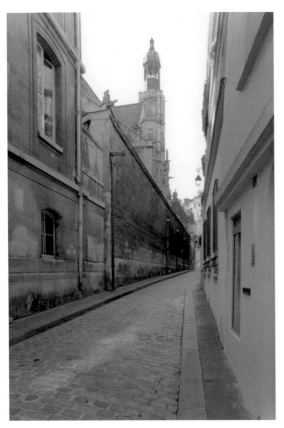

Rue Saint Etienne, 1997

Galerie Beaujolais, 1997

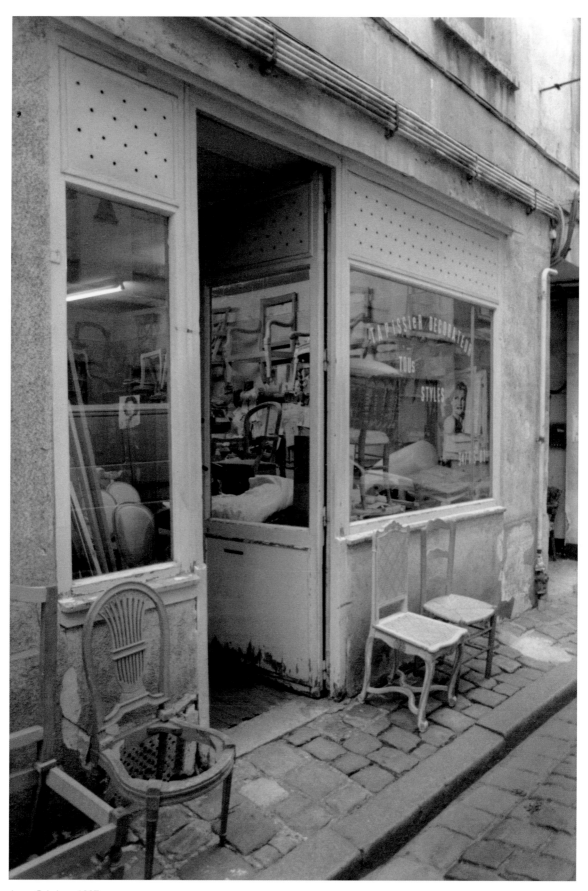

4 rue Scipion, 1997

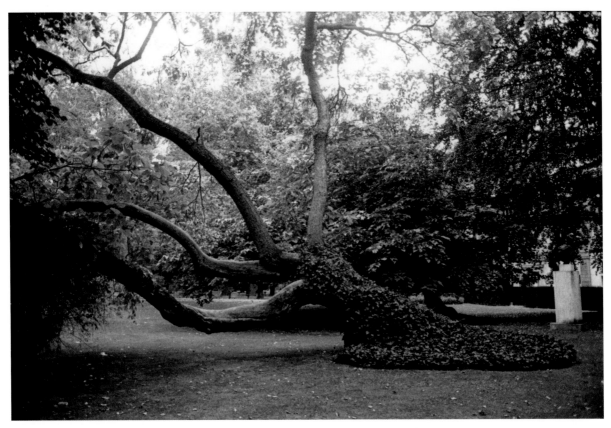

Jardin du Luxembourg, 1997

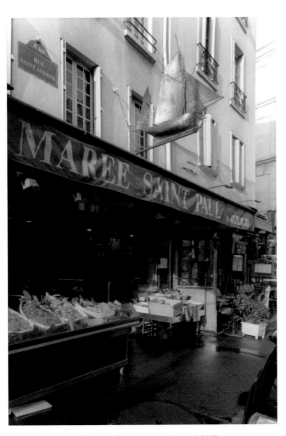

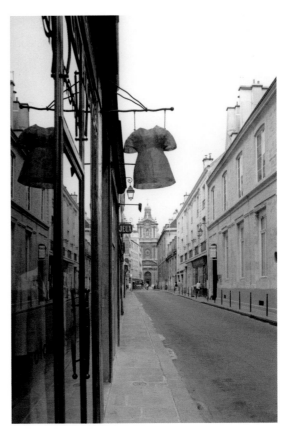

83 rue du Faubourg Saint Antoine, 1997 24 rue de Sevigne, 1998

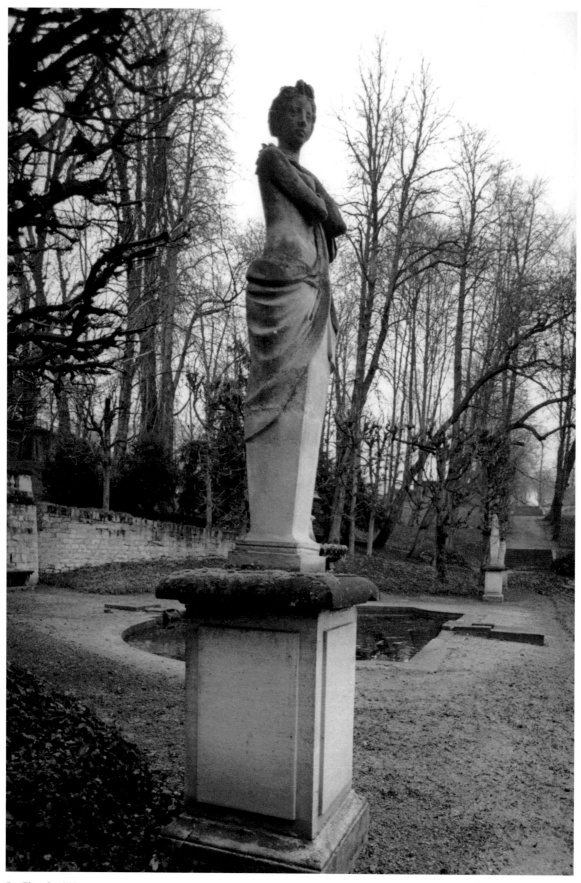

St. Cloud, 1998

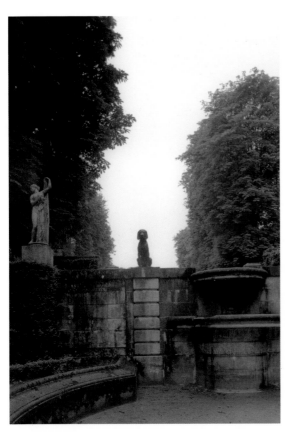

St. Cloud, 1998

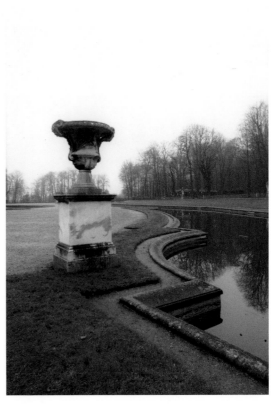

St. Cloud, 1998

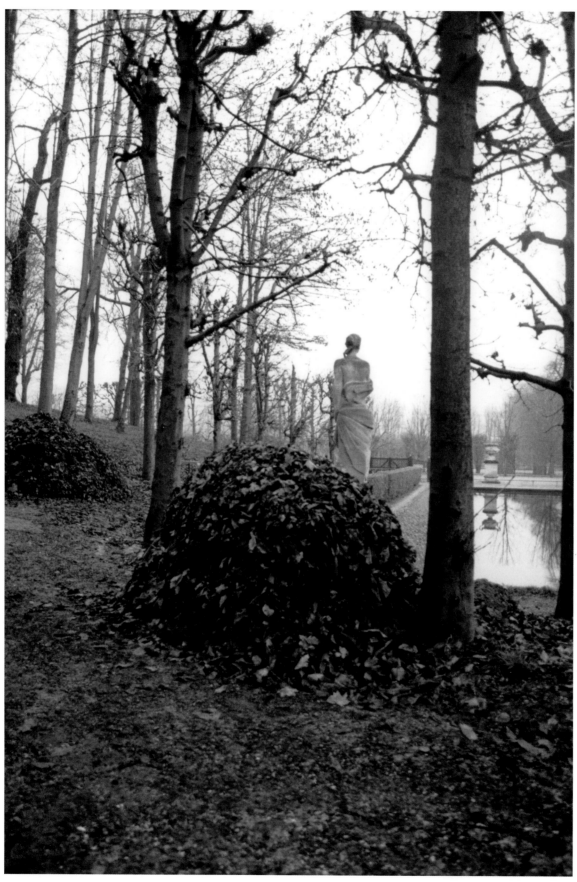

St. Cloud, 1998